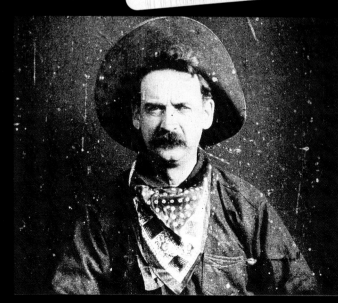

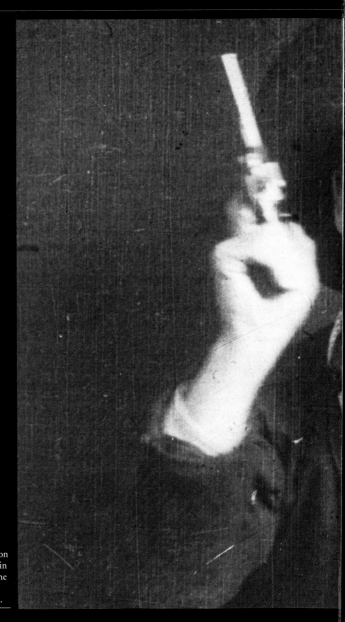

The Great Train Robbery, an Edison film directed by Edwin S. Porter in 1903, is the first Western in the history of the cinema.

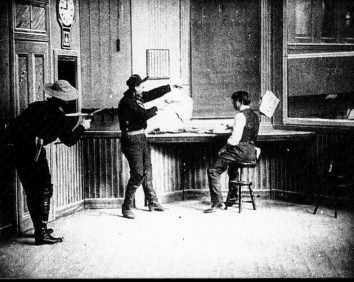

The bandits attack the telegraph office at the station,

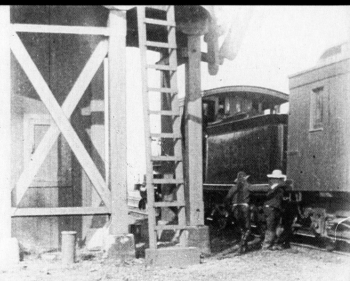

board the train, which they have stopped at the water tank,

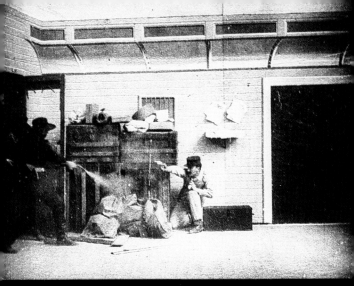

kill the post office worker, dynamite the mail car's safe,

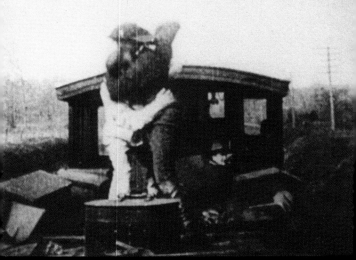

knock out the driver, and bring the train to a stop,

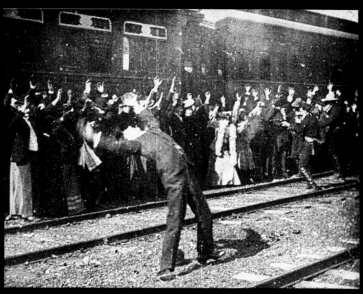

They steal the luggage and shoot someone trying to escape

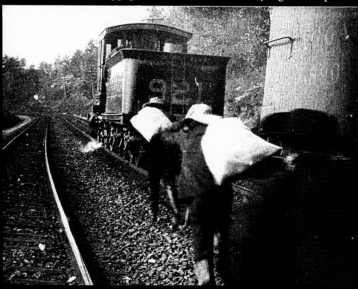

before getting away on the locomotive with the booty.

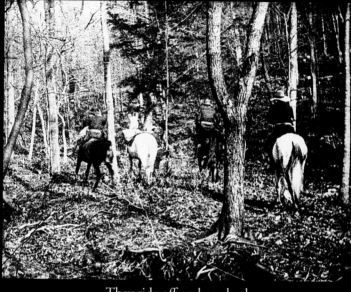

They ride off on horseback.

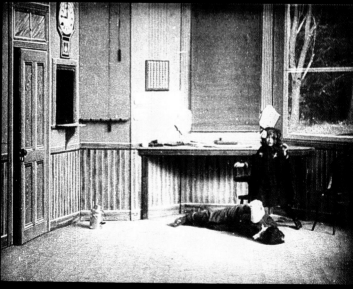

The telegraph operator is rescued by his daughter

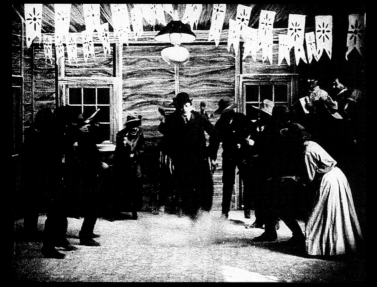

and runs to alert the men gathered in the saloon.

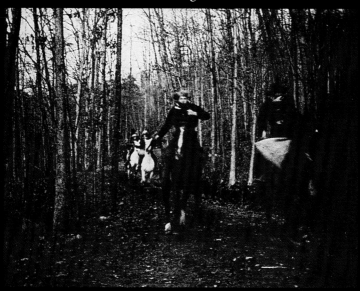

A chase ensues, and one of the bandits is mortally wounded.

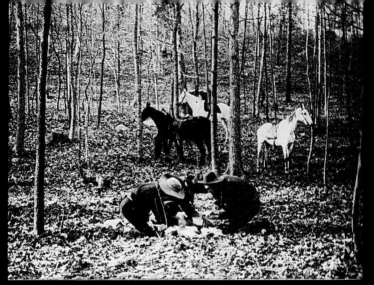

When the remaining bandits stop to divide up the booty,

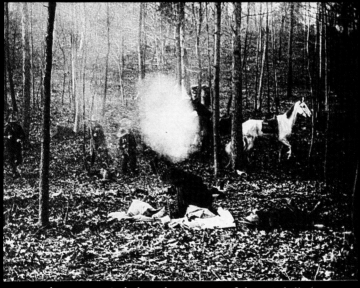

they are encircled, and every one of them is killed.

CONTENTS

CINEMA IS 100 YEARS OLD

Emmanuelle Toulet

THAMES AND HUDSON

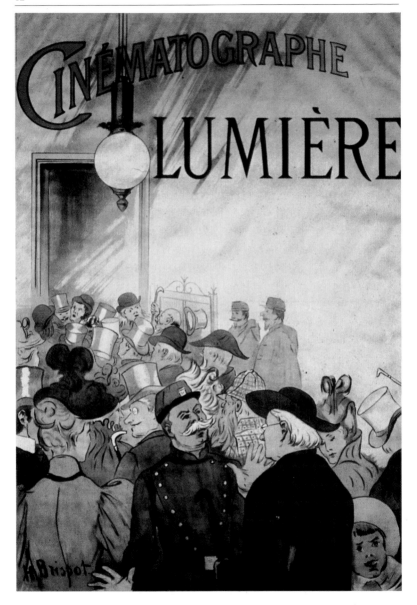

'Come to the Grand Café at nine o'clock. You amaze everyone with your tricks, but you are going to see something that may amaze even you!'

'Really? What is it?'

'Shh,' he said, 'just come and you'll see. It'll be worth it, but I don't want to give anything away. **'**

THE BEGINNING OF A NEW WORLD

Top hats, cocked hats, military caps, flat hats of priests and round hats of children – all crowded the narrow entrance to the Salon Indien. According to the first cinema poster (1896, opposite), designed by Henri Brispot, the Cinématographe Lumière was one attraction whose mystery conflicted with neither good taste nor morals. Right: from *Bataille de Femmes* (*Battle of the Women*).

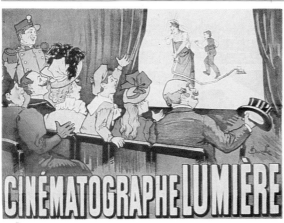

CINÉMATOGRAPHE LUMIÈRE

One evening in December 1895, Antoine Lumière entered the office of the magician Georges Méliès at the Robert-Houdin Théâtre in Paris to present him with this mysterious invitation. A bohemian and extravagant character whose adventures had begun with the founding of a photographic studio in Lyons, Lumière had come to Paris to take charge of the public presentation of the latest invention of his two sons, Auguste and Louis, who were serious, hardworking and ingenious young men.

Some members of the crowd, afraid of being crushed by the locomotive they saw bearing down on them, ran away or shrank into their seats. Below is a sketch for a poster attributed to Jules Chéret, which was never made.

28 December 1895: the first public showing of the Cinématographe

Georges Méliès would never forget that evening: 'The other guests and I found ourselves in front of a small screen, similar to those we use for…projections, and, after a few minutes, a stationary photograph showing the Place Bellecour in Lyons was projected. A little surprised, I scarcely had time to say to my neighbour: "Have we just been brought here to see projections? I've been doing them for ten years."

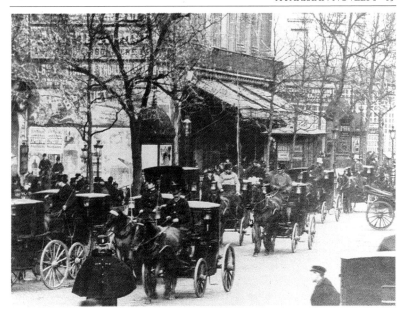

'No sooner had I stopped speaking when a horse pulling a cart started to walk towards us, followed by other vehicles, then passersby – in short, all the hustle and bustle of a street. We sat with our mouths open, without speaking, filled with amazement.'

The Cinématographe had already been shown to the scientific world at private meetings. Would public showings with an admission charge appeal to Parisians, for whom, at the end of the century, there was no shortage of novelties? Would they be attracted to the obscure, newfangled name with which the apparatus was baptized? Clément Maurice, a former employee of the Lumière company, organized the public screenings. He rented the Salon Indien, a small hall in the basement of the Grand Café at 14 Boulevard des Capucines. The setup was nothing if not basic: a cloth screen, a hundred chairs, a projector placed on a stool, and, at the entrance, a hawker announcing 'Lumière Cinématographe, Admission One Franc'.

The shows in the Salon Indien, at the Grand Café (above), lasted until 1901, but after 1896 other sites, for the most part located along the same thoroughfare, were used increasingly for screenings. The old 'Boulevard of Crime', the location of the popular 19th-century theatre, became the 'Boulevard of Cinema'.

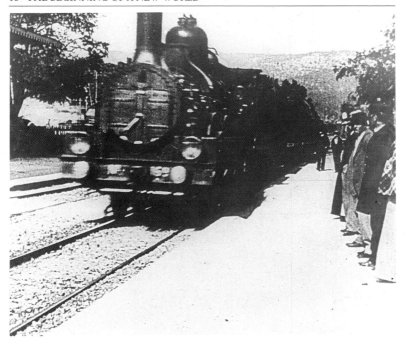

The first curiosity seekers who have entered by chance spread their enthusiasm: soon there is a crowd at the entrance to the Salon Indien

On the first day, 28 December 1895, there was little success, with only thirty-three spectators; the press, though invited, could not be bothered to attend. But after a few days, with no advertising other than word of mouth, there were crowds galore. 'Those who decided to come in left a little bewildered,' recalled Clément Maurice. 'Then, shortly after, you saw them come back, bringing along all the acquaintances they could find on the boulevard.' Before long, more than two thousand spectators were rushing to the door of the Salon Indien each day, and mobs were forming – sometimes fights even broke out. The police had to move in to maintain order.

A piano was soon installed in the dark hall to drown out the creaking sound of the machine. The twenty-minute programme consisted of ten films, and viewers all

L'Arrivée d'un Train en Gare (The Arrival of a Train at a Station) was filmed in 1896 by Louis Lumière, who placed his camera on the edge of the platform and began to turn its crank when the train from Marseilles appeared on the horizon. While the passengers wait, the locomotive approaches, grows larger and larger and finally exits screen left. The single-shot sequence lasts for fifty seconds.

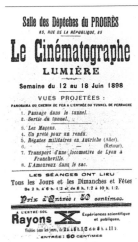

Salle des Dépêches du PROGRÈS
85, RUE DE LA RÉPUBLIQUE, 85

Le Cinématographe
LUMIÈRE

Semaine du 12 au 18 Juin 1898

VUES PROJETÉES :

PANORAMA DU CHEMIN DE FER A L'ENTRÉE DU TUNNEL DE PERRACHE

1. Passage dans le tunnel.
2. Sortie du tunnel.

3. Les Maçons.
4. Un prêté pour un rendu.
5. Régates militaires en Autriche (Aller).
6. — — (Retour).
7. Transport d'une locomotive de Lyon à Francheville.
8. L'Amoureux dans le sac.

LES SÉANCES ONT LIEU

Tous les Jours et les Dimanches et Fêtes
De 2 h. à 6 h. 1/2 et de 8 h. à 10 h. 1/2.

Prix d'Entrée : 50 centimes.

À L'ENTRE-SOL

Rayons X Expériences scientifiques et publiques.

Visibles tous les jours, de 2 h. à 6 h. 1/2 et de 8 h. à 11 h.

ENTRÉE : 50 CENTIMES.

exhibited the same reactions: sceptical or blasé at the appearance of a static photographic projection, stupefied when it became animated, admiring at the sight of the wind in the trees and the agitation of the waves, and afraid when the train entering the station at La Ciotat seemed to hurl itself at them. By the end they were enthusiastic.

Plunged into the dark, eyes strained by the flickering light, the jumping image and the jerky rapidity of any movement, the members of the audience did not feel they were present at the beginnings of a new form of spectacle. The Cinématographe seemed to them cut out for a profound but different calling: the reproduction of life – and maybe its resurrection, as one journalist's reaction bears witness: 'When these gadgets are in the hands of the public, when anyone can photograph the ones who are dear to them, not just in their immobile form, but with movement, action, familiar gestures and the words out of their mouths, then death will no longer be absolute, final.'

Film projections took place in Lyons on the occasion of a congress of French photographic societies starting in June 1895. A permanent cinema was functioning in its inventors' home-town by January of the next year.

From the start Louis Lumière proved to be a master director. His talents as a designer and photographer certainly inspired his sense of framing, spacing and lighting. Scenes of daily life, often shot with members of his family, mix spontaneity and staging, as the 1895 *Leçon de Bicyclette* (*Bicycle Lesson*, below) shows.

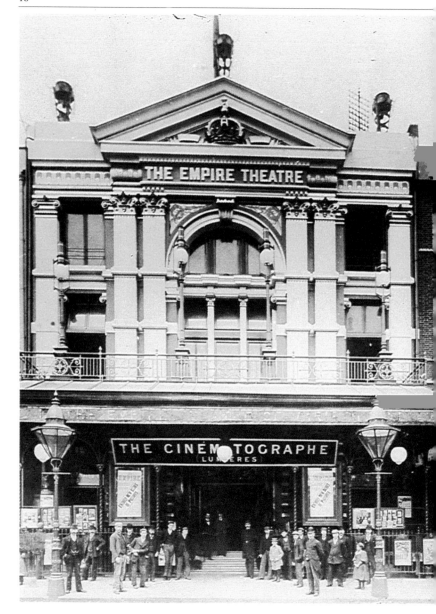

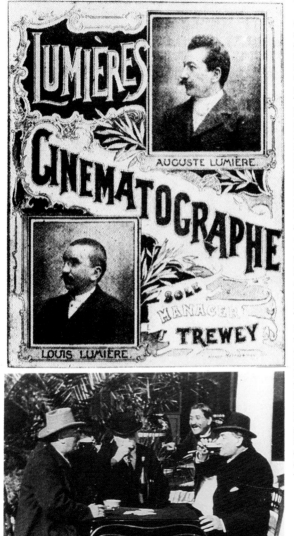

The Cinématographe soon toured the capitals of Europe. After a first public screening on 20 February 1896 at the Marlborough Hall in London, the Cinématographe was installed at the Empire Theatre (opposite), where it attracted full houses from its opening on 9 March 1896. Screenings in England (poster, above left) were organized by Félicien Trewey, a French magician and shadow illusionist who had made his name in England. He was a friend of Antoine Lumière. In *La Partie d'Ecarté* (*The Card Game*), filmed in 1895 by Louis Lumière (below left), Trewey, in the middle, plays cards with the father and father-in-law of the director. While Trewey's incursion into the world of the cinema was fleeting, his collaborator, Matt Raymond, a young English electrician, was responsible for the increased number of projectors installed in England and Ireland and would remain an important figure in the development of the cinema in Britain.

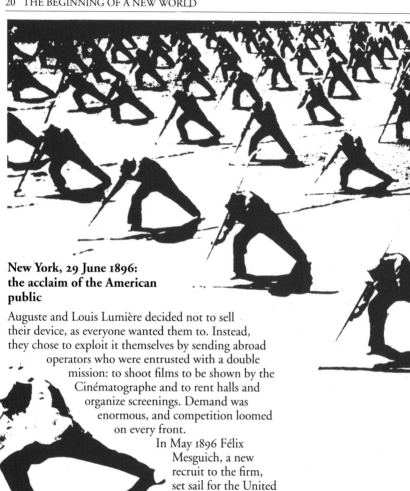

New York, 29 June 1896: the acclaim of the American public

Auguste and Louis Lumière decided not to sell their device, as everyone wanted them to. Instead, they chose to exploit it themselves by sending abroad operators who were entrusted with a double mission: to shoot films to be shown by the Cinématographe and to rent halls and organize screenings. Demand was enormous, and competition loomed on every front.

In May 1896 Félix Mesguich, a new recruit to the firm, set sail for the United States. The first American screening of the Cinématographe took place on 29 June 1896 in a New York music hall, Keith's Vaudeville Theatre, in front of a crowd of eager viewers. 'You had to have lived these moments of collective exaltation, have attended

The catalogues and lists of Lumière films offered, between 1895 and 1907, 1424 'views' divided into 337 war scenes, 247 foreign trips, 175 trips inside France, 181 official celebrations, 125 French military views, 97 comic films, 63 'panoramas', 61 maritime scenes, 55 foreign military views, 46 dances and 37 popular festivals. The image on the left is from *Parade de Sport* (*Sports Exhibition*).

these thrilling screenings in order to understand just how far the excitement of the crowd could go,' said Mesguich. 'With a flick of a switch, I plunge several thousand spectators into darkness. Each scene passes, accompanied by tempestuous applause; after the sixth scene, I return the hall to light. The audience is shaking. Cries ring out: "The Lumière Brothers, the Lumière Brothers!" ' Mesguich would also remember having been beset by journalists and carried in triumph while an orchestra played 'La Marseillaise', the French national anthem.

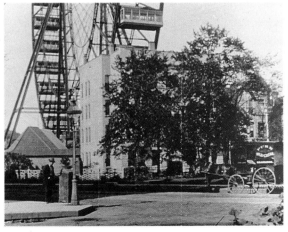

The 'city portraits' made by Lumière operators, like this view of Chicago and its ferris wheel, were intended for a dual audience – spectators eager to discover foreign countries and customs and local viewers who took pleasure in recognizing familiar places.

'America for Americans'

As word of the Cinématographe spread, people were getting impatient. Each town demanded screenings, and each week the small firm from Lyons sent new operators, who were immediately deluged with work. The French could not keep up with the demand indefinitely.

Competition was hot. In the business climate fostered by President William McKinley, rival devices surged on to the market, often accompanied by the slogan 'America for Americans'. One unabashedly patriotic advertisement read: 'The images of the American Biograph do not shake like those of the Cinématographe. The Biograph projects a much larger image than the French one. And besides, it is an American machine. So there will be more views of a national character.'

The Lumière operators ran up against new worries in

the United States. In January 1897, while filming a snowball fight in the streets, Mesguich was arrested and taken to the police station on the pretext that he did not have the proper authorization.

Five months later the Customs Service was on the company's trail, alleging that equipment was coming into the country illegally. Agents seized French projectors, and the Lumière branch director fled on a transatlantic ship.

Thus the American adventures of the Lumière Cinématographe – an ephemeral episode of only one year – came to an end, like a dream ending in a brutal awakening. However, the harvest of films shot by the company's operators during their wanderings, which took them from the New York City subway to Niagara Falls, did survive.

In his memoirs, *Tours de Manivelle* (*Cranking the Camera*, 1933), Félix Mesguich recounts his travels in the service of the Lumières in France, the United States, Canada and Russia. A man with a calling, a pioneer of both advertising films and the talkies, he was, in his own words, 'an image chaser'.

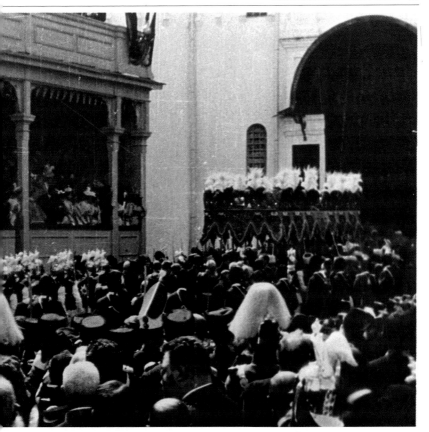

St Petersburg: the crowning of the czar and a terrible tragedy

Czar Nicholas II, who had succeeded Alexander III two years previously, was to be crowned on 14 May 1896. This exceptional subject attracted Lumière operators to Russia. For this reason, films were shot in Russia before any public screenings took place.

Intervention by the French embassy was necessary to overcome the government's distrust of the Cinématographe, which, when it was in operation, sounded like the ticking of a bomb. To house Lumière

Seven films shot by Charles Moisson and Francis Doublier on the occasion of the crowning of the czar are listed in the Lumière catalogue. This one shows the sovereigns and guests on their way to the annointing.

operators Charles Moisson and Francis Doublier and their equipment, a special stand was built; from here the first Russian films, ceremonial images of the last of the czars, were recorded.

And the camera was there two days later, when the sovereign was presented to the people and a balustrade gave way. Panic took hold of the crowd of almost a half-million people; people were trampled, and the police charged those who came near the imperial rostrum. What was the reaction of the operators to this terrible scene? They continued to turn the camera crank. They were soon arrested by the police, and their equipment was confiscated. No one would ever see their footage of five thousand dead bodies, but a new concept of journalism had been born.

The first public screening in Russia took place on 17 May at the Aquarium, St Petersburg's summer theatre. The arrival of a train – always the most striking scene – took on added resonance in the country of the novelist Leo Tolstoy: 'When on the horizon a whole train rushed at us, when it seemed to break through the screen, our minds immediately called up the same scene in *Anna Karenina*,' noted an educated witness.

On 7 July the Lumière programme, presented by Eugène Promio, made a conquest of the czar and the court. The brothers Arthur and Ivan Grünewald won the Russian franchise for the Cinématographe and engaged the most adventurous young French operators in a tour of all the Russias.

The Cinématographe touched every audience. At one fair, it evoked both the terror and anger of the peasants, who wondered, 'Was it sorcery or political propaganda?' The operator got back to his hotel under police protection, but the hall and the machine were torched.

This incident may be contrasted with a high-society scandal of the following year. Félix Mesguich filmed a famous Spanish dancer, 'The Beautiful Otero', dancing with a Russian officer at a gala evening. At the screening, the cameraman was arrested and accused of having offended the Army and was quickly thrown out of the country without further ado.

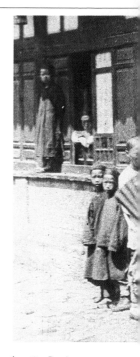

An 1899 Russian poster (below): 'For the last time! In Tambov, with the permission of the authorities…a showing of the Lumière Cinématographe will take place.'

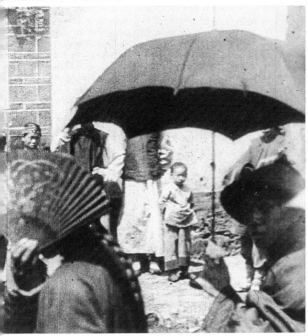

This Italian programme combined three attractions that would be closely linked until the dawn of the 20th century: X rays (discovered by Wilhelm Conrad Röntgen in 1895), panoramas and the cinema.

Gorky's 'Kingdom of Shadows': 'the strangeness of this world'

Paris, New York, St Petersburg: three of the many places in which the Cinématographe appeared, three destinies.

The future did not look bright to everyone. Behind the praise for this new step for humanity lurked an unease, vividly expressed by the Russian writer Maksim Gorky, for example, when he discovered the Lumière Cinématographe at a fair in Nizhni-Novgorod: 'Last night, I was in the Kingdom of the Shadows. If one could only convey the strangeness of this world. A world without colour and sound. Everything here – the earth, water and air, the trees, the people – everything is made of a monotone grey. Grey rays of sunlight in a grey sky, grey eyes in a grey face, leaves as grey as cinder. Not life, but the shadow of life. Not life's movement, but a sort of mute spectre.'

After having travelled across Latin America and Japan, the Lumière camera operator Gabriel Veyre went to China in 1899. Filming in the streets provoked varied reactions, evidence of which remains visible on film: thus, this fan in the foreground. Sometimes passersby approach the lens curiously until they block its view, or amused children stand in the field of vision and point to the camera with their fingers.

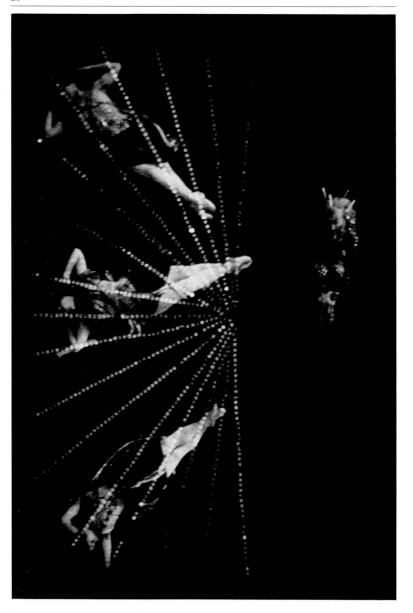

Actograph, Andersonoscopograph, Animatograph, Biactograph, Biograph, Bioscope, Bioskop, Cameragraph, Choreutoscope, Chronophotographe, Cinématographe, Eidoloscope, Eknetograph, Electrograph, Fregoligraph, Iconograph, Kineopticon, Kinetograph, Kinetoscope, Mutoscope, Panoptikon, Phantascope, Phototachygraph, Polyscope, Scenematograph, Thaumatograph, Theatrograph, Vitascope…

CHAPTER 2
INVENTION AFTER INVENTION

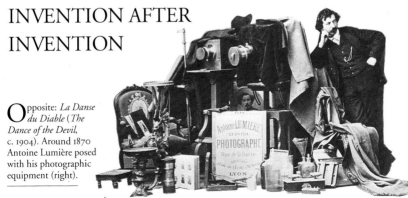

Opposite: *La Danse du Diable* (*The Dance of the Devil*, c. 1904). Around 1870 Antoine Lumière posed with his photographic equipment (right).

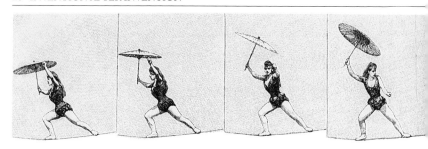

After 1890 devices for the recording and projection of moving images come thick and fast, but some problems remain unsolved

One invention led to another. Experimenters who didn't even know about each other's work sometimes obtained identical results. Five years passed in feverish excitement, with a general sense of urgency and secrecy. That any given invention was created before any other is sometimes difficult to establish, and there is another problem. How can we know if an apparatus, for which the patents are not always explicit, actually functioned, and if the product was of good quality? Also, what were the stumbling blocks around 1890?

The analysis of motion in a series of sequential photographs had already been achieved. Eadweard Muybridge, a British photographer working in California, and Etienne-Jules Marey, a French physiologist, had arrived at results of startling clarity. Further, Marey had the idea of recording images on a long strip of photographic paper that unrolled in front of the lens instead of on separate plates – but his device had no way to ensure that the movement of the strip would be regular.

An employee of a hospital for the mentally ill, Albert Londe made in 1893 these 'successive photographs' of a tightrope walker with a multiple-lens apparatus he had built to study nervous diseases.

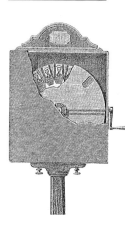

Georges Démeny, an associate of Marey, developed the Phonoscope (left and above) to demonstrate lip movements to deaf-mutes to help them learn to speak.

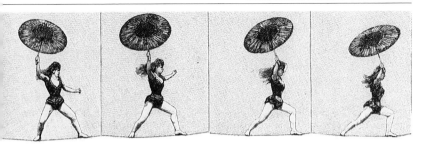

The apparatus for recording images – the moving-image camera – was also being developed. After Muybridge, who made his sequential photographs by using a series of individual cameras, some inventors built prototypes with multiple lenses; others were moving towards cameras with a single lens. The main challenge was to synchronize the movement of the raw material upon which the image would be recorded with the opening of the lens shutter.

In Germany in 1887 Ottomar Anschütz was able to re-create movement with a device using transparent chronophotographs, the Electrotachyscope.

The search for an apparatus to resynthesize motion – a projector – however, was less advanced. The basic principle – that a material able to be exposed had to be run past a light source – was widely understood. But in order for movement to be accurately resynthesized, the number of images illuminated in a second had to be identical to the number of images recorded in the same time period.

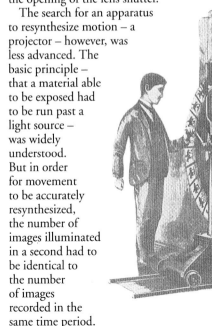
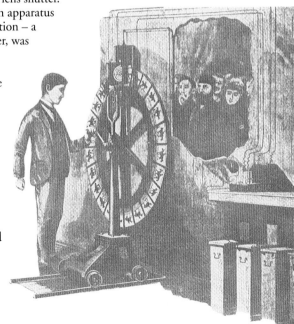

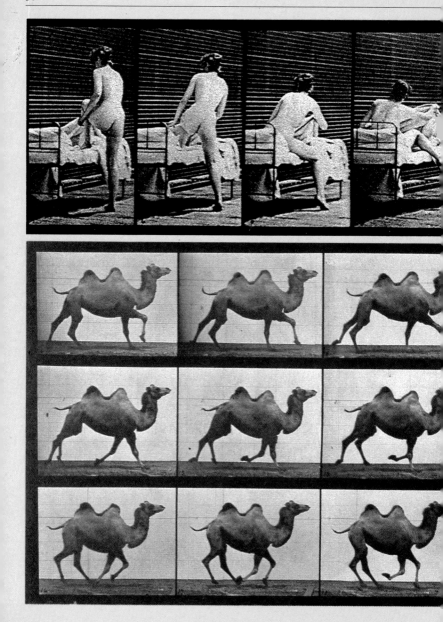

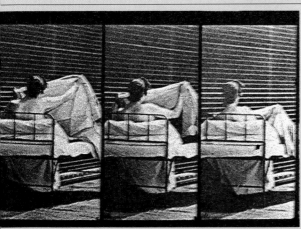

Eadweard James Muybridge

In 1872 the well-known photographer Eadweard James Muybridge, an Englishman who had emigrated to the United States, began his studies of animal locomotion by photographing horses, at the behest of Leland Stanford, who owned a major stable. Using the same technique, he studied other animals, aligning twelve, twenty-four and then forty cameras mounted with electromagnetic shutters timed to go off one after the other. By projecting these sequential snapshots, he could reconstruct movement. Later on, Muybridge analysed the movements of the human body.

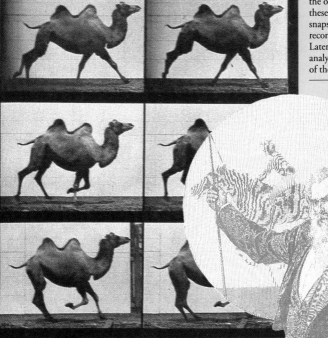

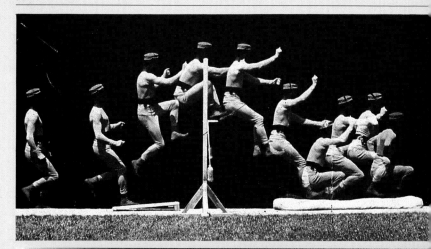

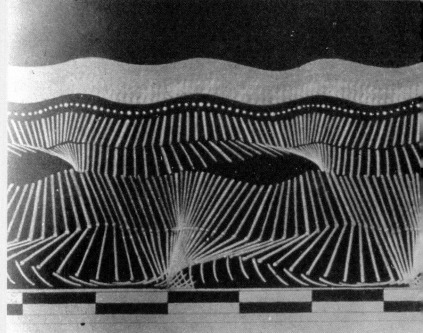

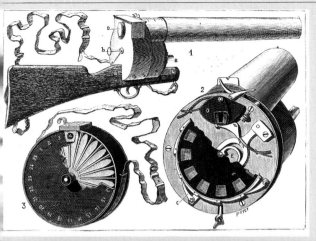

Etienne-Jules Marey

Marey studied the movement of animals, which led to his interest in photography. To understand the flight of birds, he developed in 1882 a photographic gun with which he obtained twelve images on a circular plate. He perfected his system by constructing a Chronophotographe that used rolls of paper film. He was able to deconstruct movement by photographing against a black background; first he photographed men in white (opposite above), followed by men in black clothing carrying white sticks (left). Unlike Muybridge, Marey was not concerned with putting the images back together to reconstruct movement.

So the feed mechanism played a vital role, and it is on this critical point that a solution was most eagerly awaited in the 1890s.

The most enigmatic of the unlucky inventors of cinema

On 16 September 1890 a man who had boarded the express train for Paris at Dijon disappeared without a trace. No explanation would ever be found. The man was called Louis Aimé Augustin Le Prince. In 1888 he had constructed a camera with sixteen lenses behind which two strips of film advanced intermittently. In the next year or two, he experimented with a camera equipped with a single lens, a projector with a Maltese cross – a metal part that regulates the intermittent advancing of the film – and a filmstrip made of perforated celluloid, and he managed to shoot several sequences. So all the ingredients for the cinema were in place. If the inventor hadn't mysteriously disappeared, might the cinema have been born five years earlier?

Edison tries to produce an 'instrument that does for the eye what the phonograph does for the ear'

During an 1888 lecture tour in which he displayed his experiments on human and animal locomotion with a Zoopraxiscope, Eadweard Muybridge stopped off in West Orange, New Jersey. There he met Thomas Alva Edison, a young man who had already applied for nearly a hundred patents, and who was becoming particularly well known for such noteworthy inventions as the telegraph, the incandescent lamp and the phonograph.

Fred Ott, who worked for Edison, performs his speciality in front of the Kinetograph. *Fred Ott's Sneeze* (opposite right) was the first film ever officially copyrighted, on 7 January 1894. The strip ran in a continuous loop on the Kinetoscope (below).

The World Fairs of 1889 and 1900 were the occasion of fruitful contacts among three major figures in the history of the cinema, Edison (above left), Dickson (opposite left) and Marey (opposite centre).

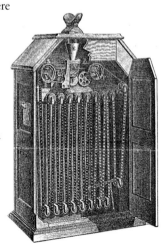

It was shortly after this meeting that the prolific young inventor conceived of a moving-image recording device based on the model of the cylinder he had already used to construct a sound-recording machine. He assigned the job of studying two apparatuses – one for the recording of images, baptized the Kinetograph, and the other for viewing them, named the Kinetoscope – to an employee with a passion for photography, the Englishman William Kennedy Laurie Dickson. The two men proceeded cautiously. Arriving in Paris for the World Fair of 1889, Edison met Marey, who told him about the progress of his own work. Eventually, in order to record photographic views, the American inventor abandoned the cylinder for a celluloid roll with perforations (sprocket holes) along each side, through which a toothed sprocket wheel would run; this ensured a uniform feed.

In his West Orange laboratories, Edison constructs the Kinetoscope

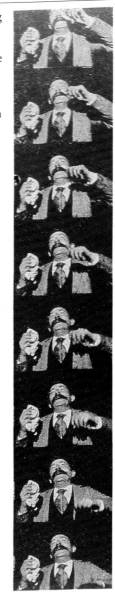

In 1889 George W. Eastman, of the company that is still known as Eastman Kodak, had begun to sell a new kind of flexible and transparent -photographic material made of cellulose nitrate. (This roll film had been developed by the Reverend Hannibal Goodwin.) When William Dickson ordered some 35-mm-wide strips of this material from the Eastman factories, one could say that 'film' was invented.

In 1891 the Kinetoscope was perfected. It was a large cabinet with a peephole through which one viewed

an animated scene recorded on a continuous loop of film. It did not allow for projection on a screen; it was purely for individual viewing. Three years later these new, coin-operated machines were made available to the public and would become another claim to fame for Edison, the 'wizard of West Orange'.

Meanwhile, Dickson makes films in the Black Maria, the world's first moving-image studio, and the business of the moving image takes shape

To supply the Kinetoscopes with material to show, Dickson assumed the job of recording films with the Kinetograph. Daylight was seldom sufficient for this task, so in 1893 a curious device was added to the installation at West Orange – a sort of misshapen black shed the employees nicknamed the Black Maria, the slang term for a patrol wagon. The world's first film studio, equipped with a roof that opened, was built on a railroad turntable, so it could rotate to capture the sunlight all day long.

Filming went on ceaselessly. The firm's employees, including Dickson himself,

No dungeons are these, thrilling with awful possibilities, but simply a building for the better taking of kinetographic subjects [the Black Maria, below].... No department of the wizard's domains is more fraught with perennial interest than this theatre; none are more interwoven with the laughter, the pathos, the genius and the dexterities of life. No earthly stage has ever gathered within its precincts a more incongruous crew of actors since the days when gods and men and animals were on terms of social intimacy.

William Kennedy Laurie Dickson, *History of the Photographic and Scientific Experiments and Developments Leading up to the Perfection of the Vitascope*, 1896

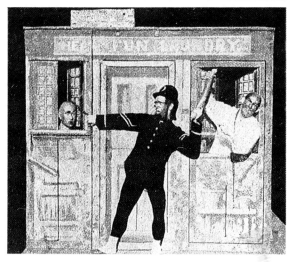

Dickson shot *Fun in a Chinese Laundry* in 1894 in the Black Maria. This film features a rudimentary set in front of a black background and a rough attempt at direction. It lasts only thirty seconds.

were the first to venture in front of the black tar paper backing that served as a set. But soon actors, athletes and artists from Barnum and Bailey's Circus and Buffalo Bill's Wild West Show were all performing there. Theatrical companies came to record a few scenes from their most recent successes. Dickson staged scripts of his own invention and also shot, outside the Black Maria, a few films in the open air.

To make scenes one minute long that curiosity seekers would watch through a peephole for the price of a nickel, performers grimaced, sneezed,

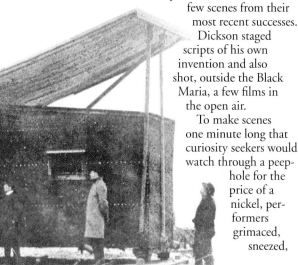

Kinetoscopes were placed at the public's disposal in special parlors, at markets, and at fairgrounds around the world. Below: a Swiss poster.

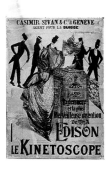

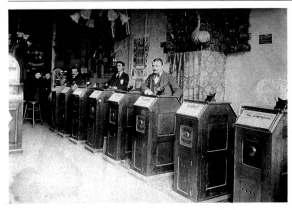

Peter Bacigalupi's Phonograph and Kinetoscope Parlor in San Francisco (left, 1894) was one of many establishments that made the new inventions available to the public for a fee.

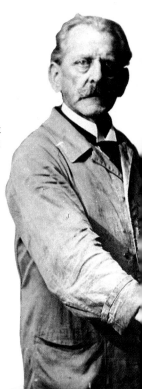

gesticulated, acted, danced and boxed. A first film of boxing found such success that a fight pitting the world heavyweight champion, 'Gentleman Jim' Corbett, against Peter Courtney was specially organized for the cinema and was promoted with an enormous press campaign. Boxing matches played an important role in the development of the early cinema; they drew outside capital and generated unusually long films.

Edison, the farsighted inventor, was a businessman of genius, to whom the Kinetoscope brought unforeseen profits. The first Kinetoscope Parlor opened in New York on 14 April 1894. Others sprang up in the large American cities, as well as in London, Paris and Mexico. The sale of machines and of films was entrusted by franchise to a few agents. Films had already become the basis of a lucrative international trade.

Max Skladanowsky, the German father of the moving image?

While the American credit for the invention of the cinema goes to Edison, and the French credit is taken by the Lumière brothers, Germans consider that the glory can be equally well granted to one of their own.

The father of Max and Emil Skladanowsky was a specialist in optical entertainment; he put on shows with a 'magic lantern', an early form of the slide projector. His sons took over the business and went on tour

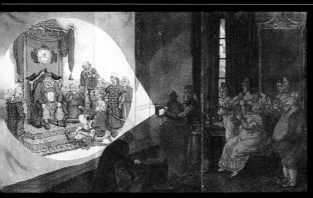

The magic lantern

The magic lantern was described as early as 1646 by the German Jesuit scholar Athanasius Kircher in his treatise *Ars Magna Lucis et Umbrae*. According to an 18th-century definition, it was a 'small machine that serves to make seen on a white wall diverse spectres and frightful monsters so that those who do not know the secret believe that they belong to the magic arts'. The scene on the upper left is of an early-19th-century magic show; below is a painted magic-lantern slide depicting the creation of the earth, a typically serious subject. Opposite: an 18th-century painting called *Magic Lantern*.

Published Nov.ʸ 18 EP by R.A.

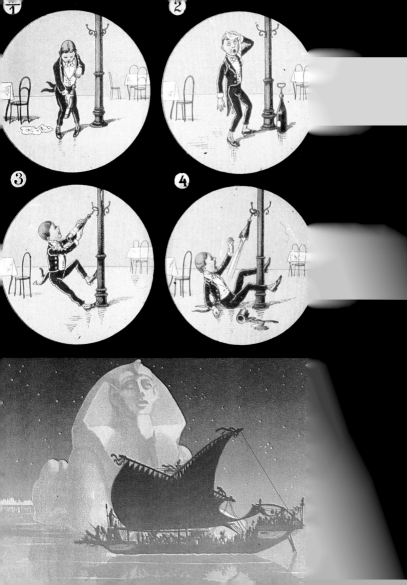

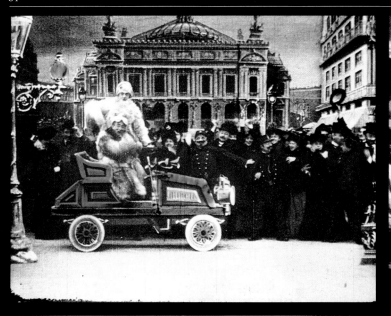

This film made by Méliès in 1905 was commissioned by the Folies Bergère, which explains the presence of several performers and the director of the famous Parisian music hall. In it, the king of Belgium, Léopold II, famous for having had many car accidents, bets that he can drive from Paris to Monte Carlo in two hours, and manages to do so after many setbacks. These four stills are taken from a coloured print of the time. King Léopold takes off in front of the Paris opera house, and makes a rapid descent (opposite); he climbs the Alps in a car, and the travellers in Dijon (this page).

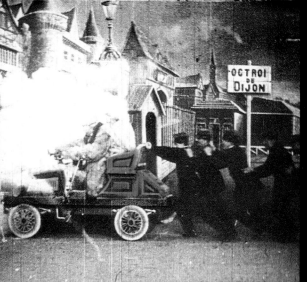

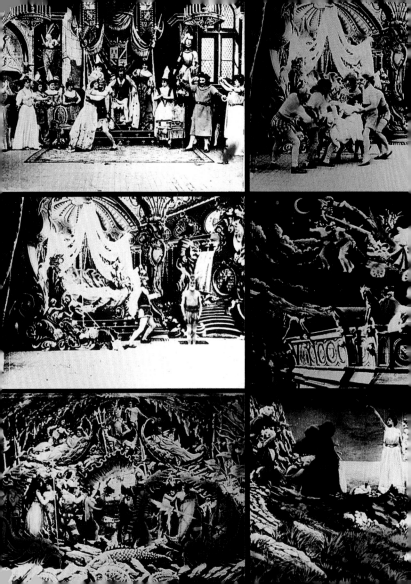

Le Royaume des Fées (*The Fairy Kingdom*)

Inspired by *The Sleeping Beauty* and made in 1903, *The Fairy Kingdom* is the first of Méliès' films to exceed three hundred metres, the equivalent of about fifteen minutes of screen time. It tells the story of the Princess Azurine, who is engaged to Prince Bel Azor in the presence of the fairies. But they have forgotten to invite the witch, who has the princess kidnapped. Bel Azor, searching for her, is shipwrecked and finds himself in Neptune's kingdom before he manages to kill the witch and rescue Azurine, whom he finally marries. Rare among the work of the director at this time, *Le Royaume des Fées* includes a scene shot outdoors, in the gardens of Montreuil, with a real horse.

Faced with the vast variety of cameras in circulation, the Lumière company had to give up its system of franchises in 1897 and turn to selling its own camera and films. Even though its output covered all genres, from the life of Christ to the advertising film, it declined in popularity, and the company ceased producing films around 1905. Its equipment manufacture and commercial exhibition would be abandoned a few years later, and the Lumière brothers, researchers and inventors at heart, would turn to other devices.

'Conquering the world, a scene by the Pathé Frères, 1894–19…'

In 1894 Charles Pathé, the son of a Vincennes butcher, exhibited an Edison phonograph at a fair. Encouraged by his first profits, he opened a phonographic shop and soon offered his clientele counterfeit Kinetoscopes imported from England. Then he teamed up with a skilful engineer, Henri Joly, who built a Kinetoscope with four peepholes, as well as an apparatus for both the recording and projection of films. In 1896 the Pathé Frères company began to sell its Kinetographs.

Pathé quickly became an important businessman who controlled several factories and studios. His firm, whose full name was 'Compagnie Générale de Cinématographes, Phonographes et Pellicules, Anciens Etablissements Pathé Frères', marketed the best cameras, endowed with an ingenious feed mechanism ensuring uniform motion by using a Maltese cross. In 1899 a Pathé

employee, a young Corsican named Ferdinand Zecca, began to produce films, and two years later he adapted a series of tableaux using wax figures from the Musée Grévin to make *L'Histoire d'un Crime* (*Crime Story*). Heartened by its success, the next year he shot *Les Victimes d'Alcoolisme* (*The Victims of Alcoholism*).

But realistic and moralistic dramas were only one aspect of the firm's proliferating production, which touched on all genres. Charles Pathé wanted to cover every subject, reach every audience and be understood in every country – and he succeeded. The cock, the Pathé emblem, came to dominate world cinema. In 1905 a new studio was built in Vincennes. While today we may be uncertain to which of Pathé's many employees to attribute a film, we do know of several members of the directorial team. Beside Zecca, there were Lucien Nonguet, Hatto, Lépine and finally, Gaston Velle, a conjurer and specialist in 'fairy films', who soon went off to work at an Italian studio.

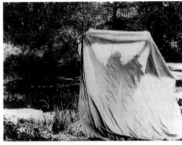

Above: from *L'Etang Enchanté* (*The Enchanted Pool*) by Ferdinand Zecca.

In *A la Conquête de l'Air* (*The Conquest of the Air*), a 1901 film, the image of Zecca astride a vehicle he invented was superimposed on a view of Paris.

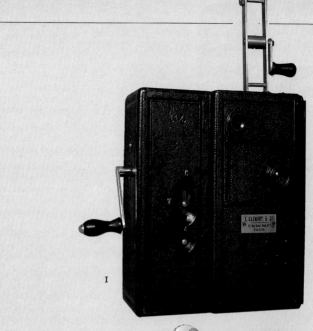

I

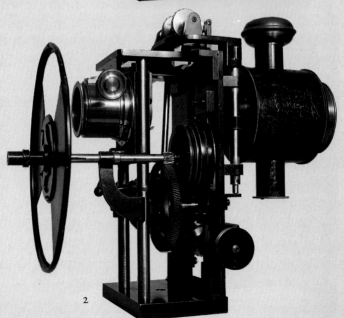

2

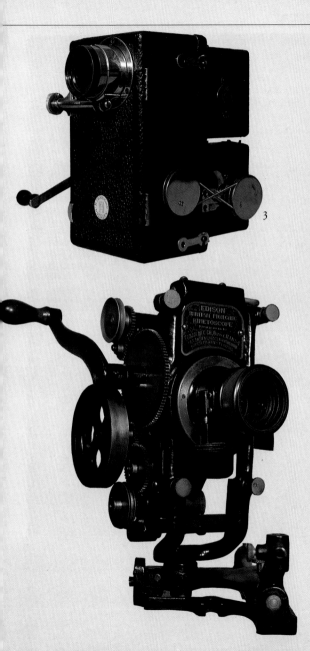

3

4

Amateurs or professionals

1) A device intended for amateur use, Gaumont's pocket Chronophotographe, the 1900 model with the Démeny system, used 15-mm film with a central perforation.

2) The mechanism of Pathé's 35-mm projector in effect copied the Cinématographe's.

3) The Ernemann amateur camera Kino I – this is the 1902 model – used 17.5-mm-wide film with a central perforation.

4) The Edison Universal Projecting Kinetoscope, 1903 model, used 35-mm film and recorded twelve frames per turn of the crank.

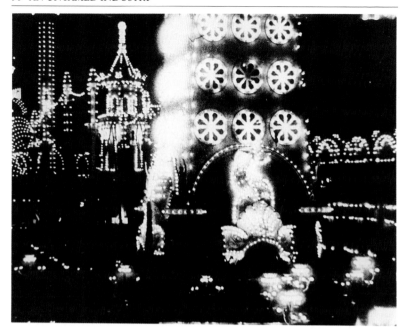

A merciless fighter, the Edison Manufacturing Company remains the top American firm until 1909

By acquiring the patent for the first American projector, developed by Thomas Armat and Charles Francis Jenkins and by presenting it under the name of Vitascope at Koster & Bial's Music Hall in New York on 23 April 1896, Edison set himself up in the United States as the inventor of the moving image. In 1898 he sued all the manufacturers, marketers and producers of films for counterfeiting or for the illicit use of his patents. Many small businesses quickly succumbed. One trial followed another, building into a veritable patent war that did not end until 1908, with the creation of the Motion Picture Patents Company, a cartel of American companies that even controlled imports.

The Edison company also proved itself formidable in the quality of its production, dominated by the

In 1905 Edwin S. Porter remade the image of Coney Island, location of the New York amusement park, by filming this documentary scene at night.

What Happened on Twenty-Third Street, New York City, a 1901 Porter film, shows street life (opposite). It ends with a shot of a woman whose skirt billows up when she walks over a subway ventilation grate.

personality of Edwin S. Porter. This young American seaman began in 1896 as an itinerant projectionist before working at a New York wax museum that quickly included cinematographic screenings among its attractions.

He became a camera operator in 1900 and, shortly afterwards, Edison's director of production. He directed two films – *The Life of an American Fireman* (1902) and *The Great Train Robbery* (1903) – that film historians consider to be decisive in the evolution of cinematographic language. After the considerable success of *The Great Train Robbery*, Porter was forced to increase his output. Especially passionate about cinema technology, he experimented in some of his films with basic technical innovations, but did not use them in all his work.

Of Edwin S. Porter (above), *Moving Picture World* said, 'He is the absolute master of his art, from A to Z. Here is no doubt the best qualified man that there has ever been to assume responsibility for a film studio.'

The American Mutoscope and Biograph Company is the most dangerous rival of the Edison Company

William Kennedy Laurie Dickson, Edison's assistant whose name is linked to the creation of the Kinetoscope and the first film strips, soon left Edison to participate in the founding of a rival firm. In 1895 he joined Elias Koopman, Harry Marvin and Herman Casler to work on the development of an apparatus that was

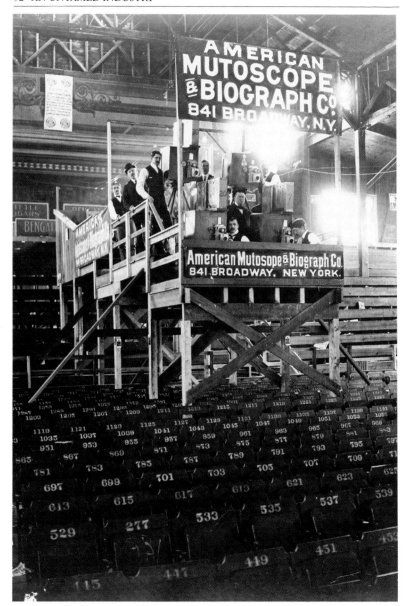

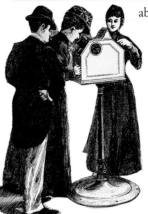

able to compete with the Kinetoscope. Their product, the flip-card Mutoscope, allowed one to see a series of photographs in quick succession. In order to record the images, they built a camera (the Mutograph), which they differentiated as much as possible from Edison's to avoid a lawsuit.

Starting in April 1896, in a revolving open-air studio on the roof of a New York building, the American Mutoscope and Biograph Company made films using a cumbersome but exceptionally fine camera called the Biograph. Johann Gotlob Wilhelm ('Billy') Bitzer, a young electrician, was hired to operate it; later, in 1908, he would become the faithful assistant of director D. W. (David Wark) Griffith, the genius of early narrative cinema. The Biograph Company stood out by making slightly erotic films, one of the important genres in the first years of the cinema.

The image wheel of the Mutoscope flipped through cards automatically when the hand crank was turned. The device's long-lasting popularity at amusement parks meant that it could still be found on the eve of the Second World War.

Opposite: to record the 1899 boxing match between Jim Jeffries and Tom Sharkey, for which it had exclusive rights, the American Mutoscope and Biograph Company built an imposing scaffold in the arena. The powerful spotlights necessary for shooting in the hall gave off such heat that the boxers had to take cover behind umbrellas between rounds.

In *Pull Down the Curtains, Suzie*, a one-shot film produced for Mutoscope in 1904, a man watches a woman undress. As the title suggests, the scene ends when she lowers the curtain before removing her undergarments.

In Britain, small production houses develop quality cinema

When Robert W. Paul discovered that no patent protected Edison's Kinetoscope in England, he quickly began to manufacture and sell forgeries. Not being able to procure Edison films, he hired a photographer, Birt Acres, to build him a camera. The two men shot their first films in the spring of 1895, and thus laid the basis for the British cinematographic industry. Paul's Animatograph Limited, which sold a projector called the Theatrograph or the Animatograph, focused, like many other firms of the era, on both marketing and production. Helped in the making of films by the magician Walter R. Booth, Paul specialized in fiction, using trick shots and original methods, traces of which would crop up in the work of Georges Méliès.

An American named Charles Urban arrived in London as the

representative of Maguire and Baucus, Edison's English agents. He transformed his office into an active company in its own right – the Warwick Trading Company – before founding his own production house – the Charles Urban Trading Company – in 1902. One of the first modern producers, he was an energetic businessman and talent scout.

In 1900 he hired George Albert Smith, a Brighton

In *The Motorist* by Walter R. Booth (1905) a car drives around one of Saturn's rings.

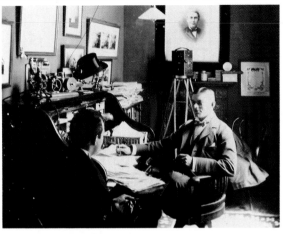

Once he became the head of the Charles Urban Trading Company, Charles Urban (left) – on the right of the picture – distributed the films of Smith, Williamson, Méliès and Lumière, and produced documentaries in his own name. His slogan was 'We put the world before you'.

photographer, who back in 1896 had fabricated a camera and had begun to make films. Urban also called on Cecil Hepworth, who soon left to found his own company in Walton-on-Thames. We owe to him one of the major films of the period, *Rescued by Rover* (1905), a fluidly told account of a dog saving an infant.

An interest in the magic lantern pushed a Brighton pharmacist, James A. Williamson, to follow his friend George Albert Smith. He made a camera around 1897, and the films he shot sold well. His productions, more important from a formal than an economic point of view, ended in 1909, and he would sell his Brighton studio to Charles Urban the next year.

Despite its exceptional narrative quality and the fundamental influence it exercised on directors of the period, British production played only a modest role in the international film market.

In making *Upside Down; or The Human Flies* (1898), Booth and Paul used upside-down sets to produce the effect below.

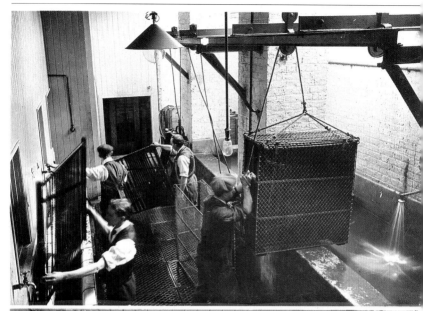

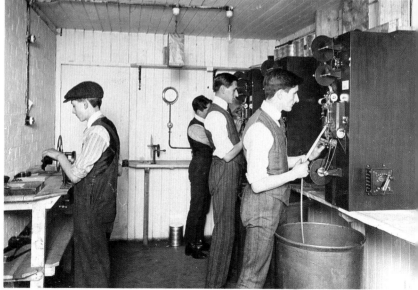

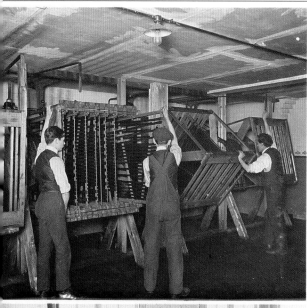

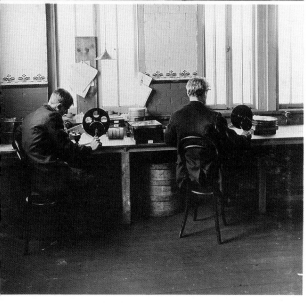

In 1898, convinced that it was possible to live off the cinema, James A. Williamson abandoned his job as a pharmacist to devote himself exclusively to film production, at which he flourished for several years. He exported a lot of material, principally to the United States and Germany. These photographs, taken in his Brighton studios, are rare glimpses of the different phases in the making of a film (left to right, from opposite above): the development of the negative, the drying, the printing of copies and the inspection of films on a winding machine.

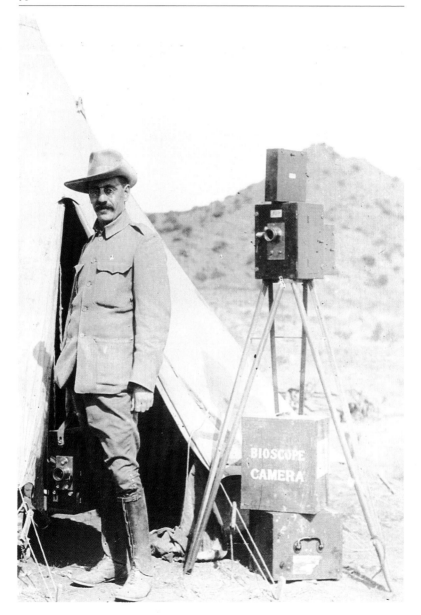

Cameras soon began to record actual events, participating in the new concept of information brought about by the rise of photography and the illustrated press. While sporting events, military parades and international conflicts were the favourite subjects of newsreel films, by recording people coming out of theatres or shopping at street markets, the cinema was also the mirror of everyday life.

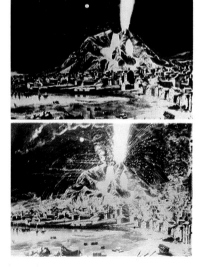

CHAPTER 5

THE DISCOVERY
OF THE WORLD

Heroism distinguished the first film reporters, such as Joseph Rosenthal (opposite). But topical films were not always authentic, like *L'Eruption volcanique à la Martinique* (right), created in the studio by Georges Méliès.

Two kinds of topical film – authentic and staged – coexist during the first decade of the moving image

The explosion of the American battleship *Maine* in Havana harbour in 1898 triggered the Spanish-American War. Cameramen rushed to Cuba. Rebuffed by the American military command, they were forced to retreat to the New York City suburbs to film battles they re-created with the help of painted backdrops, basins of water and models of ships. This is an early example of a characteristic method of reconstructing large-scale scenes in the studio.

If faked films were sometimes presented as true, or if the actual origin of a film was left ambiguous, it was not always a case of deception. In fact, some films were proudly offered as reconstructions and appreciated as such. Certain studios, such as Georges Méliès', began to specialize in this genre. Filmmakers made recourse to sham not just when the fleetingness or remoteness of an event, censorship by public authorities, or high cost prevented location shooting – but also in order to give more prominence to factual clarity and the impact of the spectacle.

The reconstructions of the Dreyfus Affair provoke the first instance of film censorship

The Dreyfus Affair – the case of an 1894 espionage charge brought against a Jewish officer in the French Army who (as it turned out after he was sent to a penal colony) had been framed – mobilized French opinion and attracted international attention for many years.

The Dreyfus Affair inspired filmmakers from Zecca – in his *L'Affaire Dreyfus* (below) – to Méliès, whose sympathy spurred him not only to make the film but also to play the role of Dreyfus' counsel for the defence (opposite below).

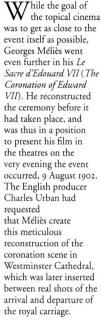

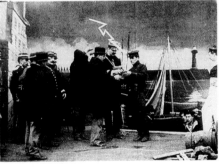

While the goal of the topical cinema was to get as close to the event itself as possible, Georges Méliès went even further in his *Le Sacre d'Edouard VII* (*The Coronation of Edward VII*). He reconstructed the ceremony before it had taken place, and was thus in a position to present his film in the theatres on the very evening the event occurred, 9 August 1902. The English producer Charles Urban had requested that Méliès create this meticulous reconstruction of the coronation scene in Westminster Cathedral, which was later inserted between real shots of the arrival and departure of the royal carriage.

So it was inevitable that the affair would be filmed. When in 1898 Francis Doublier, the Lumière company's representative, met with the Jewish communities of southern Russia, everyone brought up the unfortunate Captain Dreyfus. To respond to, and to cash in on, their expectations, the cameraman rummaged through his stock of films and cut, pasted and transformed four bland scenes into the first film of the affair. Backed by a vibrant commentary, the film was met with great enthusiasm, though it had to be taken off the market when it aroused the suspicion of an informed spectator.

The Boer War, pitting the Boers against the British, from 1899 to 1902, attracted to South Africa intrepid reporters like Joseph Rosenthal (below). This conflict proved particularly deadly for war correspondents. According to a newspaper report of the day, a third of them were wounded or killed. Left: a scene from Rosenthal's coverage.

During Dreyfus' appeal trial in 1899, the cameramen hoping for some real-life footage used all their craftiness and patience – but captured nothing but the grey and distant silhouette of a beleaguered man walking, hunched over, in a prison courtyard. It is easy to see, then, why Georges Méliès undertook a reconstruction of the whole affair in twelve scenes. In its exceptional length – fifteen minutes – and style – a realism directly inspired by press accounts – the film stands out from the rest of Méliès' work.

At the same time, Pathé

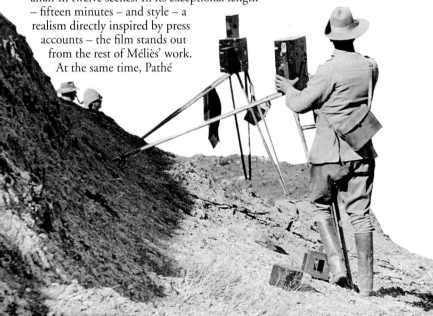

issued another version of the Dreyfus Affair.

The two films caused an uproar, attracting the attention of the police and alerting the censors. Ultimately, the government forbade the making and projection of any film on the subject. This measure, an unexpected legacy of the first years of the cinema, would not be lifted until 1950.

Lumière films like *Les Coolies dans les Rues de Saïgon* (*Coolies in the Saigon Streets*) were shot by young people who had never previously travelled and who had no journalistic training. The fresh look that they cast on the world led them to record scenes that would no doubt have been ignored by news professionals.

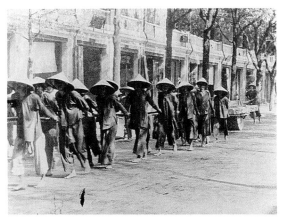

Camera operator: a new profession and a modern form of adventure

Poorly defined, jobs in film were often ephemeral or done on the side, as moonlighting. If the case of Georges Méliès – at the same time producer, scriptwriter, director, set designer and actor – is extreme, one person's combining of several functions was not rare.

Pioneers in a new world, camera operators played a fundamental role – they captured images, to be sure, but they also served as founders of national film industries by establishing the bases for commercialization, production and distribution. Many have remained unknown. Some took up this young career by chance, quitting it, like most of the Lumière cameramen, when their contracts came to an end.

Others, already professional dealers in information, like journalists or photographers, approached their craft

Cinema programmes were always heterogeneous. Here, the factbased film is followed by *Cendrillon* (*Cinderella*).

differently, employing this new technology to best advantage.

The first true film reporter, Joseph Rosenthal, was not a journalist, but a photographic technician working in London for the moving-image entrepreneur Charles Urban. When the Warwick Trading Company sent him to South Africa in 1900 to follow the British troops fighting the Boers, he travelled with two cameras and two mules. Coming very close to the combat, he shot more than five thousand metres of film.

Unfortunately, it did not all make it back to London. Some of it was stopped by the censors, and other pieces disappeared en route when a convoy was captured by the enemy or when a boat sank. The old era of battles between ranged ranks of massive troops was fading away, and with no long-range lenses to use, Rosenthal's films showed that guerrilla fighting did not look good on film, and European and American reconstructions soon appeared in the film houses to compete with his authentic war films. Enjoying great renown, Rosenthal would follow all the great world conflicts at the beginning of the century – in China, the Philippines and Japan.

The Cinéorama, a circular cinema, tries to simulate the experience of a balloon trip

The name of Raoul Grimoin-Sanson will be recorded in film history not for the Phototachygraph (even if it was one of the Cinématographe's first competitors), but rather for a device called the Cinécosmorama, based on which he built a novel form of entertainment, the Cinéorama. This celebrated attraction never really got off the ground, so to speak, and in retrospect it was more of a utopian idea than a reality.

The Cinécosmorama, patented by the inventor in 1897, was an apparatus formed by ten radiating cameras, which permitted filming and projection in 360 degrees. More than anything, the device evoked the concept of the panorama and the

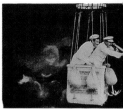

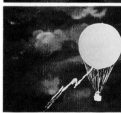
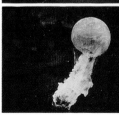

From *Un Drame dans les Airs* (*Drama in the Air*, 1904).

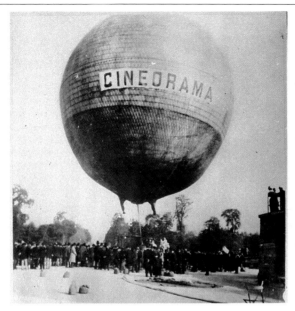

idea of a voyage, much in the spirit of the time.

Grimoin-Sanson conceived of a vast circular building one hundred metres in circumference, whose white walls served as a continuous screen. The centre of the hall was occupied by an immense balloon gondola equipped with the usual accessories – anchor, rigging, sacks of ballast and a ladder. The ceiling was covered with a hanging designed to imitate the balloon itself, with its tackle, ties, ropes and valve opening. The ten synchronized cameras were placed under the gondola and, when the lights were dimmed, would project views of balloon ascents, voyages and landings (the latter achieved by running the film backwards).

This project was approved by the commissioners of the Paris World Fair of 1900 and Grimoin-Sanson undertook to bring it to life. He had the cameras built and then shot the film footage on board real balloons soaring above the capitals of Europe. But technical imperfections ruined this grandiose enterprise. The heat thrown off by the projectors was unpleasant for the

Above: the Cinéorama balloon in Paris, 1900.

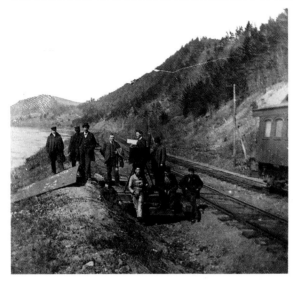

On a track in Pennsylvania in 1896, the Edison camera crew and railroad agents work on *Black Diamond Express*. Fiction films frequently integrated different types of train footage, offering the spectator alternately the points of view of a conductor, a passenger and a cow watching the train go by.

spectators and created a fire risk, so the police ordered the establishment to be closed after only four performances.

An experiment without a successor, the Cinéorama seems more an ultrasophisticated avatar of the dioramas so popular in the 19th century than a prefiguring of the complete visual experience the cinema would try to become in the 20th.

The train and the cinema are an inevitable combination at the turn of the century

'Suddenly, you hear something click; everything disappears, and a train occupies the screen. It heads straight for us – watch out! You could say that it wants to bear down into the dark where we are, to make of us an unspeakable heap of torn flesh and broken bones, and reduce to dust this hall and the whole edifice filled with wine, music, women and vice.'

This apocalyptic vision in which the filmed train, in an instant, appears as the avenger who strikes a depraved society belongs to the writer Gorky. The 'primitive scene' of the film – the arrival of

a train at a station – is a recurrent theme in the early stages of the cinema. Locomotives stopped bursting through screens when cameramen, often followed by spectators, set up shop in railroad cars. The first lateral travelling shots – shots in which the camera moves, which were called panoramas at the time – were taken through train doors. The most intrepid of cameramen crouched on the front of engines and filmed the passing landscape, as it was swallowed up. The train and the cinema were thus combined, and this association contributed to the rise of the American film industry.

Some of Hale's Tours were commissioned by railroad companies. Thus, around 1898, in Orange, New Jersey, the cameraman Billy Bitzer shot an advertising film for a railroad company with a Mutograph camera attached to the bumpers of a locomotive.

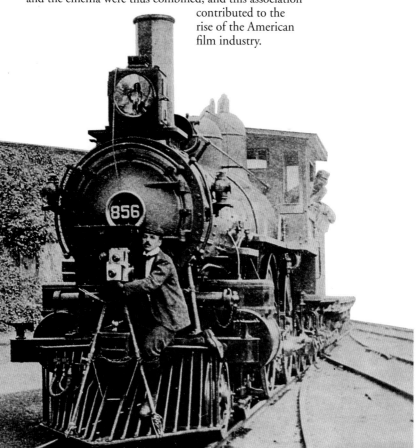

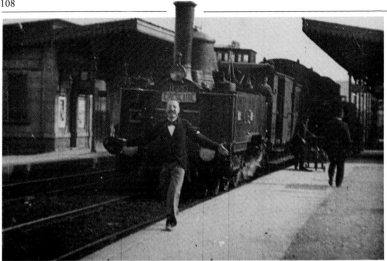

The 'train cinema'

Fire chief of Kansas City for more than twenty years, George C. Hale was endowed with an undeniable knack for business. In 1904 he bought the patent for an invention by William J. Keefe consisting of a train car running on circular tracks through a tunnel; the tunnel's translucent sides served as a screen upon which films of landscapes were projected. Hale simplified Keefe's invention. His train car didn't actually move – instead its front was replaced with a film screen, and a gadget underneath simulated the rattles and sounds of a moving train. The 'train cinema' was one of the novelties exhibited at the great St Louis World's Fair in 1904, along with the ice cream cone, the hot dog and iced tea.

The spectacle known as Hale's Tours is the basis of an American industry

Beginning in 1905, the attraction, baptized Hale's Tours, spread across the United States, making the fortunes of its promoters – including, among others, Sam Warner, Adolph Zukor and Carl Laemmle, who would figure among the greatest Hollywood producers some years

Scenes of trains arriving at stations were very popular in the first years of the cinema. In this one the man running in front of the train adds a narrative dimension and fresh emotional tone to the film.

Newspapers reported that spectators watching the projection of a Hale's Tour called out to pedestrians appearing on the screen so that they would get out of the way. One man came back to the screenings every day, hoping to witness a derailment.

later. Zukor, the future president of Paramount Pictures, opened the first New York Hale's Tour in a building resembling a train station, staffed by employees in uniform who ushered the spectators into a hall seating sixty, for a half-hour trip. Five-cent Hale's Tours flourished across the country, particularly in amusement parks, forming the first permanent chain of cinema theatres.

After 1905 Hale's Tours were transformed into nickelodeons, whose name linked the five-cent coin and the Odeon, the Greek word for theatre.

The illusion, reinforced by the opening shots of rails streaming under the train, was convincing. In fact, travel films shot from the front of moving vehicles soon became an established genre listed in the catalogues of most American production companies. Cameras explored every country in the world, for the exhibitors were always wary of monotony and strove to find the new and the exciting. But monotony inevitably did set in, and by around 1912 Hale's Tours had disappeared.

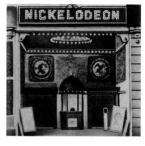

In an attempt to overcome public disaffection, Adolph Zukor inserted a successful fiction film, *The Great Train Robbery* (1903), directed by Edwin S. Porter, into his show. This landmark film brought together once again the train and the early cinema and played a key role in the evolution of cinematic language.

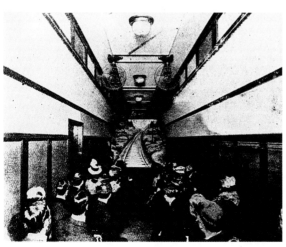

● The hall was about fifteen metres deep and the seats were on the two sides with a central aisle, exactly as in a railway carriage, with the same type of cane-backed seats. The film had been taken from a train crossing the Andes. I stayed there with a friend, another kid, and for us it was like a fairy tale. We spent the whole day watching this spectacle and did not get back to earth until they threw us out in order to clean up. ●

Byron Askin
American director

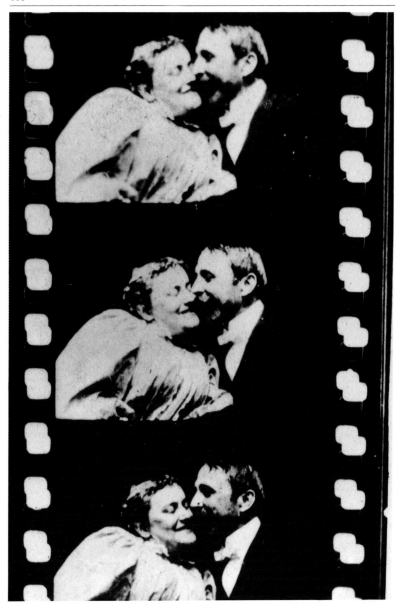

‘The public has seen too many trains, trams and buses. And with the exception of a few films whose humour is too French to please the British, one could say that no one up to now has begun to exploit the possibilities of moving pictures, to make us laugh, cry or be amazed.**’**

Robert W. Paul, 1898

CHAPTER 6
IMAGES RUNNING WILD

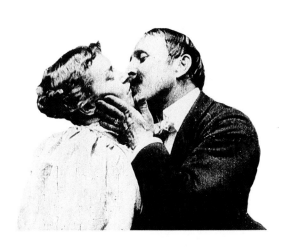

This kiss, no doubt the first one in cinema history, is the sole subject of the film *The May Irwin–John C. Rice Kiss* (1896), not the climax of a romantic story.

The magic lantern lies at the heart of film narration

The composition and aesthetic of early films trace their roots back to several narrative forms popular at the end of the 19th century, among them the magic lantern and the comic strip.

The magic lantern, which furnished the cinema with some of its first artisans, also offered a repertoire of subjects and suggested a mode of telling a story in a sequence of tableaux. Its influence was felt particularly strongly by British directors: James A. Williamson and George A. Smith regularly organized magic-lantern projections, and Cecil Hepworth was the son of a famous projectionist and author of a reference manual on the subject.

A series of magic-lantern slides often culminated in a shot taken from close-up – in it one can see the antecedent of the concluding

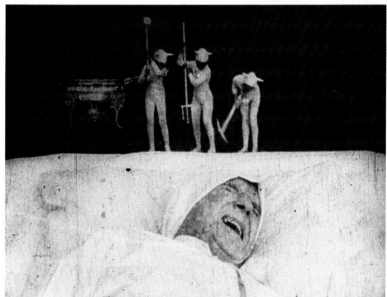

close-up in the cinema. The lecturer's commentary in magic-lantern shows influenced films by making it clear that certain elements did not need to be made explicit in the images themselves but could be revealed in sound during their projection.

The impact of the comic strip

The fierce competition being waged between the New York press magnates Joseph Pulitzer, owner of the New York *World*, and William Randolph Hearst, owner of the *Morning Journal*, encouraged the American comic strip, which flourished, in colour, on the first page of the Sunday supplements of both dailies. The comics supplied the cinema with ideas for scripts and characters, and bad boys from the school of Buster Brown or the Katzenjammer Kids abounded on the screen. Happy Hooligan, the hero of the first comic strip drawn by Frederick Burr Opper in 1899, turned up the following year in a series of films, while *The Dream of a Rarebit Fiend* by Winsor McCay inspired a film of the same name by Edwin S. Porter in 1906.

In Edwin S. Porter's *The Dream of a Rarebit Fiend*, a man staggers home and gets into bed, having overindulged in beer and cheese fondue. He has a nightmare – his bed shakes, rushes out of the bedroom and flies over New York. The man falls out of bed and finds himself hanging on the steeple of a church before waking up on the ground, in his bedroom. The film is linked to the comic strip of the same title by Winsor McCay by its effects. Drunkenness is expressed by a shot of the actor clinging to a lamppost filmed by a moving camera, superimposed on a rapid horizontal panorama of the landscape. As well as superimposition, Porter's bag of tricks included frame-by-frame shooting, the horizontal division of the screen, a reduction in size of the characters and the combination of shots of several scales.

The structure of the comic strip also had an influence on the emergence of cinematic language: Full-page

features were divided into panels equivalent to film shots which furthered the story while varying the viewing angle, scale and location. Several comic strips, like *Buster Brown* or *Little Nemo*, began with full-page drawings that introduced the story but were not a real part of it. This initial image can be compared to the close-up with which many films opened. But, all parallels aside, in the first years of the century, film directors were far from attaining cartoonists' narrative virtuosity.

Vaudeville had a great influence on the nascent cinema

When Dickson shot the first Kinetoscope films, he borrowed scenes from New York music halls and travelling theatre troupes. In some of his films, the sets resembled theatre backdrops; the artist came on stage, saluted, performed his or her number and exited; and the camera had the best seat in the house, in the centre in the middle distance. Filmed variety acts, which generally consisted of a single shot, were screened in music halls, in the spirit of the original.

Framing and depth of field

Directors learned very early on how to play with these elements. In fact, Lumière's *L'Arrivée d'un Train en Gare* offers one of the oldest and most striking examples of the change of scale within a single shot. Lumière's films are remarkable in that he employed traditional standards of composition; his films are framed like photographs.

In James A. Williamson's *The Big Swallow* (1901), a gentleman who is reading discovers an amateur photographer who has his head under the camera's black cloth and is already in the process of taking his photograph. The gentleman orders him to leave, and comes closer and closer, gesticulating and shouting, until his head occupies the whole frame. Finally his mouth alone fills the entire screen. He opens it, and first the camera, then the photographer, disappear inside. He walks away chewing and expressing the greatest satisfaction.

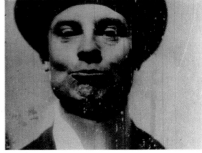

Though wide-angle scenes in a frame inspired by the theatrical stage were predominant, directors did employ closer framings and variations in scale. The movements of actors – who entered and exited at the back or at the sides of the field – were borrowed from theatrical stagecraft.

Close shots – which include only the head and shoulders of an actor – or close-ups – which reveal only a hand or face – were not uncommon. They ranged from the face of Georges Démeny mouthing '*Je vous aime*' in front of the Chronophotographe in 1891, to *Record of a Sneeze* for the Kinetoscope in 1894, or the kiss of two actors (*The May Irwin–John C. Rice Kiss*) for the Vitascope in 1896. In fact, such shots even constituted a genre, one of whose favourite subjects was the play of facial expression, particularly grimaces. Close shots, generally showing the principal actor, could be placed either at the opening or closing of a film; in fact, *The Great Train Robbery* was delivered to exhibitors with a shot of the chief bandit shooting right at the camera; it could be placed at the exhibitor's discretion. Another frequent finale was an apotheosis in the form of a tableau vivant, a set of frozen poses.

In *The Big Swallow*, the man advances towards the camera, which remains stationary. The cameraman had to modify the focus constantly so that the image stayed sharp. *Concours de Grimaces* (*The Grimace Competition*, below), by Ferdinand Zecca, is a series of close-ups of faces with no narrative link.

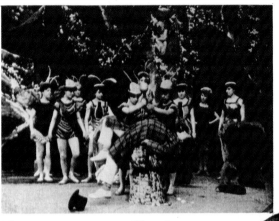

In *La Peine du Talion* (*Tit for Tat*, 1906), the view of the entomologist with a pin through his middle, filmed with an overhead camera, is followed by a full shot of the butterflies having their revenge.

The camera moves: travelling shots and panoramas enlarge the scenic space

Other innovations involved the position of the camera. While it was generally placed at the actors' eye level, filmmakers found that it could be raised or lowered to achieve certain effects. Some trick effects were obtained by placing the camera overhead, directly above the scene.

But, at first, the camera did not move. While Lumière's films demonstrate a remarkable expertise in framing and the use of depth of field, they consist of a single static shot. Therefore, in 1897, when cameraman Eugène Promio filmed the palaces of the Grand Canal in Venice from a moving gondola, he claimed to have made the first travelling shot in the history of the cinema.

Grouped in film catalogues under the heading 'panoramas', travelling shots, whether forwards, backwards or side to side, and whether taken from a train, boat, balloon, car or lift, proliferated in documentary films well before 1900. They soon made their way into fiction films, though they were rarely used unless they could be justified or explained by the plot involving some means of locomotion.

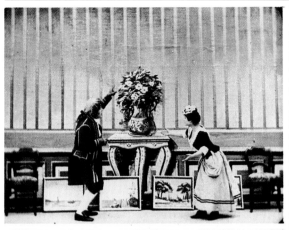

In *L'Ingénieuse Soubrette* (*Magic Picture Hanging*, 1902) Zecca not only filmed from overhead, but he placed the wall decoration in such a way that one has the impression that the maid is walking up the wall to hang the pictures. She beckons several times to the viewer, explaining in gestures what she is going to do, and then she thumbs her nose. The practice of addressing the camera would become taboo before too long, since it destroyed the illusion of the autonomy of the cinematographic world.

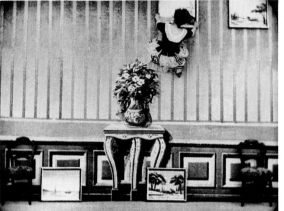

In many cases characters moved from the background up to a stationary camera. *Hooligan in Jail*, produced by the American Mutoscope and Biograph Company in 1903, offered a daring example of a forwards travelling shot, starting with a view of the whole cell, and moving to a close-up of the vagabond eating his prison food. This was an innovative way to join two views, an alternative to simply cutting. But this step was not followed up. Instead of having the camera change position, Georges Méliès, adapting a theatrical device for

the cinema, had his painted backdrops move instead, unrolling horizontally in front of the camera.

After 1900, when they were shooting on location, camera operators were fond of panning – pivoting – to follow a character or an action, which sometimes seems to be more a clumsy reframing of the scene than a deliberate effect. In about six years, these movements, which had by then become familiar in fiction films, had acquired a function in the story. Pans appeared in films made in the studio at Pathé in 1905 and would remain a characteristic of films made by the foremost French production company for many years.

Camera movements could reveal the existence of an off-screen space where part of the action could be taking place, allowing viewers' imaginations to fill in the gaps between shots.

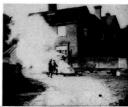

The chase, that great device of early cinema, introduces several innovations

The majority of fiction films were composed of a single shot. The oldest known examples of films with multiple shots are from 1898, and belong to Georges Méliès (*La Lune à un Mètre/The Astronomer's Dream*) and to Robert W. Paul (*Come Along, Do!*), which combines an interior and an exterior scene. By around 1900 films whose plots required several shots were often conceived as a series of shots, each of which bore a distinct title. Six years later films containing about ten shots and lasting ten minutes were quite common.

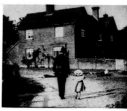

A policeman running after a bandit, a dog pursuing a vagabond, a grocer chasing a thief, a woman searching for her husband – the chase gave rise to longer films, consisting of several shots, made on location. Escaping studio sets, which aimed at an illusion of three-dimensionality, actors took to the streets, tumbled down stairs, forded rivers and scaled barricades. To run more easily, women lifted their skirts, and the sight of an ankle was not the least of the attractions of the chase film, even though feminine roles were often played by cross-dressing men when acrobatics were called for.

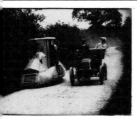

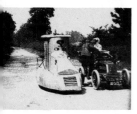

The moving chase

Chase films, born in England, were quickly adopted in France and then in the United States. They shared an identical structure. Each shot was in a different location and, generally, the protagonists came out of the background, moved towards the camera, and left the shot diagonally, the camera sometimes panning to stay with them longer. The chased and the chasers thus traversed the field of vision one after another, and not until a scene was empty did the shot change. The pursuit on foot was quickly followed by chases on horseback, in cars and on trains, which led to shorter shots and a faster pace.

The Motor Pirate, by the Englishman Arthur Melbourne-Cooper (1906), is an early chase film. In twelve shots, the modern bandits, behind the wheel of a futurist vehicle – in fact, a disguised Panhard – attack a farmhouse and threaten its occupants. They are chased by the police, but the strange vehicle swallows one of the officers. After attacking other drivers, the bandits end up stuck in a river. *The Motor Pirate* seems to mock the innumerable chase scenes of the era, which were triggered by the most minor of pretexts and used the most varied means of locomotion. Here, the theft of chickens provokes the chase, and the plunge into the river puts an end to it.

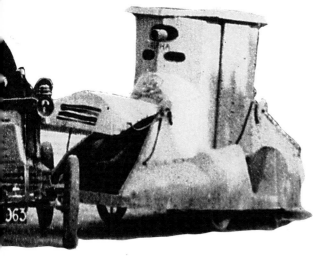

Directors could convey the complexity and evolution of a story without recourse to editing

Simultaneous actions could be represented by juxtaposing them in the same shot, either by showing two places side by side on a painted backdrop, dividing the set with a partition, or by superimposing one image on another, completely or partially, by masking out one image and then exposing the film again. Telephone conversations were depicted by dividing the screen, showing the two interlocutors, and sometimes reserving a third of the space to convey either the content of their dialogue or simply the distance separating them. The superimposition of one image on another was especially used to represent the subjectivity of a dream, a memory or words.

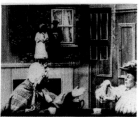

The change of place inside a shot could be indicated by a pan of the camera. In *The Little Train Robbery* (Porter, 1905), a parody of *The Great Train Robbery*, the camera follows the fleeing bandits and then pivots, coming back to their victims on the train.

Multiple shots did not always add up to a continuous story, as breaks or ellipses were numerous. *Uncle Tom's Cabin*, for example, directed by Edwin S. Porter in 1903, assumed that spectators were already familiar with Harriet Beecher Stowe's novel, since the story is so condensed and chopped up.

Superimposition helped tell a story visually. *What the Curate Really Did* (1905, left) shows a curate talking to a young girl and then in a series of superimpositions shows gossiping women distorting the story. As the film progresses from shot to shot, the little girl grows up until she finally becomes a woman whom the curate embraces.

In *L'Affaire Dreyfus* (opposite above), the screen is divided into three superimposed parts to depict a telephone conversation.

Zecca showed the dream of a condemned man in *L'Histoire d'un Crime* by using a specially designed set (opposite below).

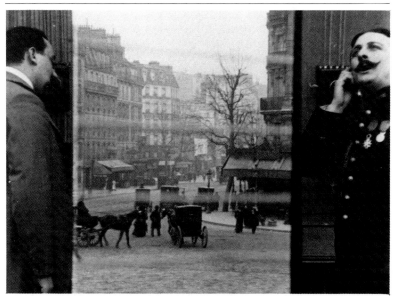

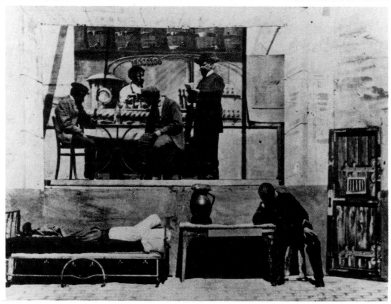

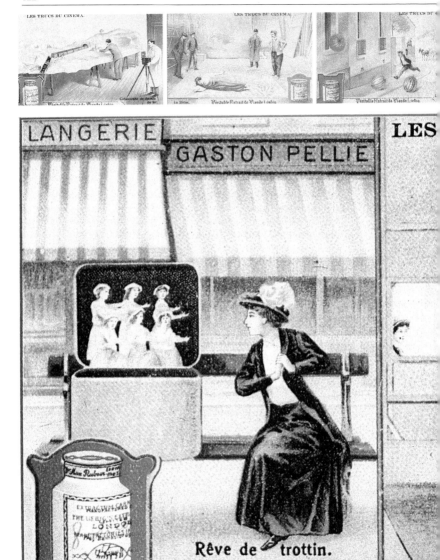

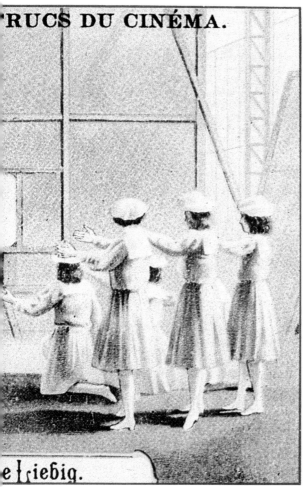

These postcard advertisements for Liebig's meat extract show how various trick shots from popular cinema were filmed. Left to right, top row: *Catastrophe de Chemin de Fer* (*Railway Disaster*) was made with miniature models. Using a film of fish swimming in an aquarium, the creators of *La Sirène* (*The Mermaid*) recorded a woman pretending to swim. *La Fuite de Potirons* (*The Pumpkins' Escape*) was created by filming pumpkins rolling down a hillside street while the man ran backwards towards the cart. When the film is played backwards, it appears that the pumpkins flee up the street. The car in *L'Accident d'Automobile* (*The Automobile Accident*) was filmed running over the artificial limbs of a legless man. The camera was stopped, and an actor dressed in the same way replaced the man. The burglar climbs up the set of a facade filmed from above in *La Dextérité d'un Monte-en-l'Air* (*The Dexterity of a Cat Burglar*). Main picture: the special effect in *Rêve de Trottin* (*Dream of an Errand Girl*) was made by creating an opening in the backdrop corresponding exactly to the basket lid. The basket was opened, the camera was stopped and the scene resumed with the girls in position.

When a film consists of several shots, the director faces a new problem: editing and linking them

The oldest mode of transition between shots was the dissolve, an overlap between one shot and another, a device first used by Georges Méliès that was quickly adopted in American and other French productions. For example, all the shots in Ferdinand Zecca's *L'Histoire d'un Crime* (1901) and Edwin S. Porter's *The Life of an American Fireman* are joined by dissolves. Dissolves began to lose favour after 1903, and only Méliès would persist in their use.

The British introduced the use of the simple cut between two shots, done before the field of vision became empty or the action in question was carried to completion. Two films by James A. Williamson, *Stop Thief!* (1901) and *Fire!* (1902) thus had a completely novel feeling. In them, the action is not followed from one shot to another continuously but is partially repeated in the second shot. This specific device was used in the early years of the cinema when there was a change of place or a change of framing of the same event.

Again, an Englishman, this time George Albert Smith, was the first to divide the same scene into several shots and insert close-ups between the wide shots. First, the

⁶ Perhaps the film that most dramatically uses the close-up to increase the sense of both voyeurism and eroticism is *The Gay Shoe Clerk* (Edison). It changes from a long shot to a close-up of the salesman and his female customer, with a close-up of his hands tying her shoe. The film then cuts to a long shot of him kissing her. In effect, the sudden change in camera position from a long to a close shot indicates, even hypostatizes, the intense erotic desire which the characters have come to feel for each other. ⁹

John Hagan
film historian

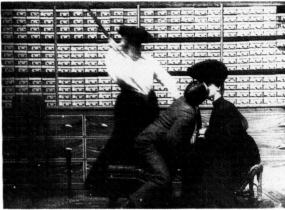

presence of a magnifying glass, a telescope or a keyhole would signal to the viewer that a close-up would follow; and then it would appear, the image circumscribed by a black mask around the edges of the frame, emulating the shape of the object theoretically being looked through. Shots of the characters watching something alternated with close-ups showing what they saw. After 1903 close-ups served not only to indicate the actor's point of view but also focused the attention of the spectator on a

I n *A Wonderful Hair Restorer*, the shot of Zecca examining this man's bald cranium with a magnifying glass is followed by a masked close-up. This type of shot, which shows what the actor is looking at, is called a point-of-view (or subjective) shot.

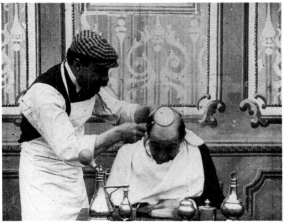

detail of the scene without the intervention of optical instruments or masks.

This was a time of much variety and experimentation. Clichés had not yet developed. One method of getting from one shot to the next would be used one time, and another device would be used the next. Chase films would experiment with varied points of view, as well as

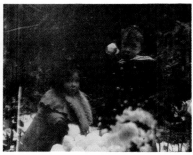

shot-countershot sequences, but such techniques did not catch on widely.

The Great Train Robbery, the first Western, is one of the great popular successes at the beginning of the century

This film reveals remarkably well how a story could, after only a few years of fiction cinema, be told. Edwin S. Porter linked scenes one after another without dissolves, by using simple cuts that came before the dramatic action or logic of the scene was played out entirely. The basic unit of the film is not the tableau, but the shot, and the film's fourteen shots, particularly the exteriors, are dynamic.

The Great Train Robbery's success attests to the fact that a wide public was already familiar with the new artistic form and its mode of expression, to the point of enjoying, beyond technique or novelty, the potentials of emotion and suspense. In the organization of scenes showing the evil deeds of the bandits and those shots presenting the preparations of the forces of justice, one

A remarkable shot-countershot, this view of children filmed from behind throwing snowballs at the glass door of a house is followed by a shot from the front as they throw their snowballs at the camera lens (*Their First Snowballs*, 1907).

New York was the capital of American cinema, and most of the exteriors were shot in New Jersey in those days. But the sun, wide-open spaces and natural beauty of southern California attracted film crews, and the business moved west around 1910. Opposite below: Hollywood in 1905.

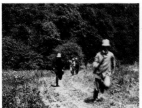

A nomalies of time were customary in early cinema. When one changed the angle of vision in shooting a chase, one reshot the scene from an earlier stage. Here, in *The Little Train Robbery*, the position of the characters is repeated, one step further back, in the following shot.

can see the precursors to the way in which a few years later D. W. Griffith crosscut between multiple developing scenes to tell several stories and express the simultaneity of two or more actions.

But the cinema was still so young. Griffith, whose name would mark the beginning of a new era in cinema history and stand for the art of silent film, was still a poverty-stricken young man, dreaming of being a writer, trudging from one New York production house to another in the hope of peddling a script or getting a bit part. And Hollywood was still a sleepy, sun-drenched valley, known only for its fruit.

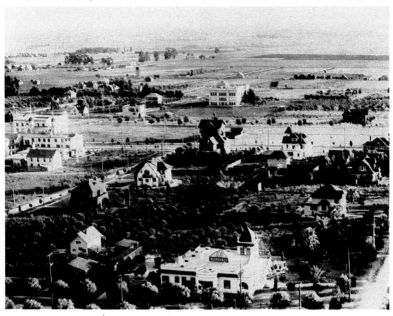

DOCUMENTS

First impressions, first thoughts

The press proved relatively sparing in its coverage of the first screenings. These published comments only hint at the excitement that must have been felt at the time.

Messieurs Lumière, father and son, from Lyons, last night invited the press to the inauguration of a really strange and novel spectacle, whose première was reserved for the Parisian public. They have installed their ingenious apparatus in the elegant basement of the Grand Café in the Boulevard des Capucines.

Imagine, if you will, a screen placed at the back of a vast room. This screen is visible by a crowd. On the screen appears a photographic projection. So far, nothing new. But suddenly, the image – of either natural or reduced size, depending on the scene's dimensions – animates itself and comes to life.

It is a factory gate, which opens and releases a flood of workers, male and female, with bicycles, running dogs and carriages – all swarming and milling about. It is life itself; it is movement captured on the spot.

Or else there is an intimate scene, a family gathered around a table. Baby lets some porridge, which his father is feeding him, fall from its lips, while the mother smiles. In the distance, the trees are swaying; the breeze lifts the child's ruffle....

Photography no longer records stillness. It perpetuates the image of movement. The beauty of the invention resides in the novelty and ingenuity of the apparatus.

When these gadgets are in the hands of the public, when anyone can photograph the ones who are dear to them, not just in their motionless form, but with movement, action, familiar gestures and the words out of their mouths, then death will no longer be absolute, final.

La Poste, 30 December 1895

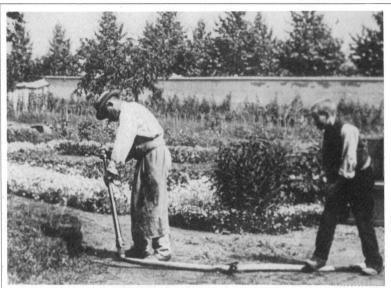

Inspired by a famous picture story, *L'Arroseur Arrosé* was shot by Louis Lumière in the family's vegetable garden during the summer of 1895.

A new invention by Thomas A. Edison was shown to a few favored persons last night. The new machine is really a grown up kinetoscope, and it is a success.

Mr Edison calls his latest invention the Vitascope, which he says means a machine showing life, and that is exactly what the new apparatus does.

The vitascope, which has been in process of perfection at the Llewellyn laboratory for the last seven or eight months, under Mr Edison's direction, is the ideal he had in mind, he says, when he began work on the kinetoscope machine, with which he has never been satisfied.

The vitascope is an improvement of the kinetoscope, by which moving life size figures of men, women and animals are thrown upon a screen by means of

bright lights and powerful lenses. The trial of the new machine was made last night in a cold corner of the big foundry at the works, and Mr Edison, with Richard N. Dyer, William J. Gilmour, manager of the phonograph work Raff & Gammon, of New York, and a few invited guests huddled around a red hot stove and gazed at and admired the marvellous figures thrown upon the big white screen at one end of the room.

The first picture shown was a colored panorama of a serpentine dance by Anabelle, who went out to West Orange to pose one day last summer. The film roll on which the photographs were attached was arranged over a half dozen spools and pulleys, and the machine was set in motion.

Even the inventor himself was surprised at the result, although with

his usual critical eye he discovered flaws in the film which he declared must be disposed of before the vitascope would come up to his ideal.

<div align="right">

New York Herald
4 April 1896

</div>

That settles scenery. Painted trees that do not move, waves that get up a few feet and stay there, everything in scenery we simulate on our stages will have to go. Now that art can make us believe that we see actual living nature, the dead things of the stage must go.

And think what can be done with this invention! For instance, [the singer Albert] Chevalier comes on the screen. The audience would get all the pantomime of his...songs. The singing, words fitted to gestures and movements, could be done from the wings or behind the curtain. And so we could have on the stage at any time any artist, dead or alive, who ever faced Mr Edison's invention.

<div align="right">

Charles Frohman
New York theatre magnate
The New York Times
24 April 1896

</div>

Every seat in the theatre was sold ere the box office window was opened for the evening's business. Standing room only was sold, and the purchasers of it formed a fresco around the entire circuit of the walls from box to box in addition to which some hundreds who applied for seats left, to come again later in the week. So much for what was expected of the management, and it can be said but in a few words, the immense audience was not disappointed....

<div align="right">

Los Angeles Herald
7 July 1896

</div>

The vitascope is a wonder, a marvel, an outstanding example of human ingenuity, and it had an instantaneous success on this, its first exhibition in Los Angeles.

<div align="right">

Los Angeles Times
7 July 1896

</div>

The report by the novelist Maksim Gorky took on quite a different tone.

Last night, I was in the Kingdom of the Shadows.

If one could only convey the strangeness of this world. A world without colour and sound. Everything here – the earth, water and air, the trees, the people – everything is made of a monotone grey. Grey rays of sunlight in a grey sky, grey eyes in a grey face, leaves as grey as cinder. Not life, but the shadow of life. Not life's movement, but a sort of mute spectre.

Here I must try to explain myself before the reader thinks I have gone mad or become too indulgent towards symbolism. I was at Aumont's restaurant and I saw the Lumière Cinématographe, the moving pictures. This spectacle creates an impression so complex that I doubt I am able to describe all its nuances. I shall, however, try to convey the essentials.

When the lights are extinguished in the hall where we are to be shown the Lumière brothers' invention, a great grey image – the shadow of a poor engraving – suddenly appears on the screen; it is *Une Rue de Paris*. Examining it, one sees carriages, buildings, people – all motionless – and you predict that the spectacle will have nothing new: views of Paris, who has not seen them so many times? And suddenly, with a curious click on the

screen, the image is brought to life. The carriages that were in the background of the image come right towards you. Somewhere in the distance people appear, and the closer they get, the more they grow. In the foreground children play with a dog, bicyclists turn and pedestrians try to cross the street. It all moves, breathes with life, and suddenly, having reached the edge of the screen, disappears one knows not where.

This is all strangely silent. Everything takes place without your hearing the noise of the wheels, the sound of footsteps or of speech. Not a sound, not a single note of the complex symphony which always accompanies the movement of a crowd. Without noise, the foliage, grey as cinder, is agitated by the wind and the grey silhouettes – of people condemned to a perpetual silence, cruelly punished by the privation of all the colours of life – these silhouettes glide in silence over the grey ground. Their movements are full of vital energy and so rapid that you scarcely see them, but their smiles have no life in them. You see their facial muscles contract but their laugh cannot be heard. A life is born before you, a life deprived of sound and the spectre of colour – a grey and noiseless life – a wan and cut-rate life.

It is terrible to see, this movement of shadows, nothing but shadows, the spectres, these phantoms; you think of the legends in which some evil genius causes an entire town to be seized by a perpetual sleep and you think you have seen some Merlin work his sorcery in front of your eyes. He has bewitched the whole street, compressed the high buildings; from roof to foundations, they are squeezed into a space that seems to be only a metre wide; the people were shrunk proportionally at the same time as their ability to speak was stolen, and as the earth and the sky were plundered of their coloured pigment and draped in the same grey monotone.

This grotesque creation is presented to us in a sort of niche at the back of a restaurant. Suddenly, you hear something click; everything disappears, and a train occupies the screen. It heads straight for us – watch out! You could say that it wants to bear down into the dark where we are, to make of us an unspeakable heap of torn flesh and broken bones, and reduce to dust this hall and the whole edifice filled with wine, music, women and vice.

But no! It is only a cortege of shadows.

Maksim Gorky
Nijegorodskilistok
4 July 1896

This Russian poster was annotated by a French camera operator to correspond with the order of the programmed projection.

Lumière remembers

The author Georges Sadoul took the opportunity to interview the charming Louis Lumière in 1948. The elderly man remembered much about the historic events of more than a half-century earlier.

I had not the honour of knowing the great inventor who has just died when I received from him in August, 1946, a manuscript consisting of some dozen pages entitled 'Observations suggested to Louis Lumière by reading Georges Sadoul's book entitled: "L'Invention du Cinéma" '. In this monograph he had taken the trouble to rectify certain errors in the first volume of my Histoire Générale du Cinéma, completing my data on a number of points.

M. Louis Lumière received me a few weeks later at Bandol. In the course of this long interview – and of those which followed – he furnished me with a large body of information concerning his cinematograph, and this enabled me to prepare a very much augmented and corrected edition of 'L'Invention du Cinéma.'…

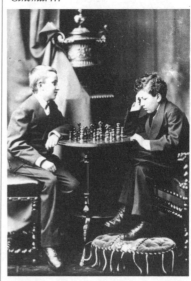

Louis and Auguste Lumière photographed by their father.

In January last [1948], M. Louis Lumière, whose health had been steadily declining since 1946, was kind enough to allow me to interview him for the French television service....

A lengthy afternoon's work was required. M. Louis Lumière, who at that time scarcely left his bed, had to make a considerable physical effort in reading, at the cost of great exertion, the text which he held before his almost sightless eyes. However, under the projectors and in front of the microphone he maintained his usual smiling affability. This was the last time he was confronted by the apparatus on which he had bestowed the name 'Cinéma'.

Last March [1948] this interview was televised: it opened the series of remarkable broadcasts which Georges Charensol devoted to the history of the cinema, with the collaboration of Pierre Brive. It is thanks to their initiative that the cinema is able to retain among its archives a final picture – and an extremely touching one – of Louis Lumière.

SADOUL: M. Louis Lumière, what were the circumstances in which you began to be interested in animated photography?

LOUIS LUMIERE: It was during the summer of 1894 that my brother Auguste and I commenced our first work. At that period, the research of Marey, Edison and Démeny had caused those inventors to arrive at certain results, but no projection of film on a screen had yet been accomplished.

The main problem to be solved was that of finding a system of driving the strip of film pictures. My brother Auguste had thought of using for the purpose an indented cylinder, similar to

that proposed by Léon Boully in another apparatus. But such a system was clumsy. It couldn't work and never did.

SADOUL: Did M. Auguste Lumière then put forward other systems?

LOUIS LUMIERE: No, my brother ceased being interested in the technical side of the cinematograph as soon as I had found the right driving device. If the cinematograph patent was taken out in our joint name, this was because we always signed jointly the work reported on and the patents we filed, whether or not both of us took part in the work. *I was actually the sole author of the cinematograph,* just as he on his side was the creator of other inventions that were always patented in both our names....

SADOUL: Did you have to wait long before using celluloid films similar to those employed by the modern cinema?

LOUIS LUMIERE: I would have used celluloid strips at once had I been able to obtain in France a flexible, transparent celluloid which gave me satisfaction. However, no French or British firm was then making any. I had to send one of our departmental managers to the United States, who purchased celluloid in nonsensitized sheets from the New York Celluloid Company, and brought them back to us at Lyons. We cut them and perforated them with the aid of an apparatus whose feed device was based on that of a sewing machine, which apparatus was perfected by M. Moisson.

SADOUL: What was the date when you were able to make your first film on celluloid?

LOUIS LUMIERE: It was at the end of the summer of 1894 that I was able to make my first film, [*La Sortie d'Usine*]

Workers Leaving the Lumière Factory.
As you may have noticed, the men are wearing straw hats and the women summer dresses. Moreover, I needed strong sunlight to be able to make such scenes, for my lens was not very powerful, and I should not have been able to take such a view in winter or at the end of autumn. The film was shown in public for the first time at Paris, rue de Rennes, before the Société d'Encouragement pour l'Industrie Nationale. This was on March 22, 1895. This showing ended a lecture which I had been asked to give by the illustrious physicist, Mascart, of the Institute, then President of the Society. I also showed on the screen the formation of a photographic image in course of development: this involved certain difficulties that I won't go into here.

SADOUL: Was your apparatus already called the cinematograph?

LOUIS LUMIERE: I do not think we had already baptized it. Our first patent, taken out on February 13, 1895, did not adopt any particular name. In that patent we merely referred to 'an apparatus for obtaining and showing chronophotographic prints'. It was not until several weeks afterwards that we selected the name cinematograph....

SADOUL: Did the perfection of your cinematograph involve you in technical problems that were difficult to solve?

LOUIS LUMIERE: One of the points which received my attention was that of the resistance of the films. Celluloid films were then, to us, a new product of whose qualities or properties we were ignorant. I therefore embarked on methodical experiments by piercing the strips with needles of different diameters, to which I suspended increasing weights. I thus arrived at important conclusions, for instance that the hole might, without inconvenience, be larger than the pin passing through it and have equally as good resistance as if the hole and the pin were the same size....

SADOUL: Since in 1895 you only had a single apparatus which served both for taking pictures and for showing them, during that year you were the sole operator taking pictures for your cinematograph?

LOUIS LUMIERE: That is correct. All the films which were shown in 1895, either at the Photographic Congress of Lyons in June, for the Revue Générale des Sciences in Paris in July, or in Paris, the basement of the Grand-Café, from December 28, 1895, onwards, were films for which I had been the operator. There was a single exception: *Les Bruleuses d'Herbes* [*The Grass Burners*] was taken by my brother Auguste, who was on holiday at our estate in La Ciotat. I should add that not only did I make these films, but the first strips shown at the Grand-Café were developed by me in enameled iron slop-buckets containing the developer, then the washing water and the fixative. The relevant positives were similarly printed and I used as source of light a white wall with the sun shining on it.

SADOUL: Can you, M. Lumière, tell us about the *Partie d'Ecarté* [*The Card Game*]?

LOUIS LUMIERE: The partners are: my father, Antoine Lumière, who lights a cigar. Opposite him, his friend the conjurer Trewey, who is dealing the cards. Trewey was, moreover, the organizer in London of showings of our cinematograph, and he is to be seen in several of the films, *Assiettes Tournantes* [*Spinning Plates*] for instance. The third

player, who is pouring out some beer, is my father-in-law, the brewer Winkler of Lyons. The servant, finally, was a man attached to the house. He was born at Confaron – a pure-blooded southern Frenchman, full of gaiety and wit, who kept us amused with his repartee and jokes.

L'Arrivée du Train en Gare [*The Arrival of a Train at a Station*], which I took at the station of La Ciotat in 1895, shows on the platform a little girl who is skipping along, one hand held by her mother and the other by her nurse. The child is my eldest daughter, afterwards Mrs Trarieux, and she is now four times a grandmother. My mother, Mrs Antoine Lumière, can be identified by her Scotch cape.

SADOUL: What can you tell us about the famous *Arroseur Arrosé* [*The Sprinkler Sprinkled*]?

LOUIS LUMIERE: Although my recollections are not very accurate, I think I may say that the idea of the scenario was suggested to me by a farce by my younger brother Edouard, whom we unhappily lost while an airman during the 1914–1918 war. He was then too young to play the part of the urchin who treads on the garden hose. I replaced him by a young apprentice from the carpentry workshop of the factory, Duval, who died after performing his duties as chief packer of the works for almost forty-two years. As regards the waterer, the part was played by our gardener M. Clerc, who is still alive after being employed by the works for forty years. He is retired and is now living near Valence.

SADOUL: How many films did you make in 1895?

LOUIS LUMIERE: I must have made nearly fifty. My memory is not very reliable with regard to the number of these subjects. These films were all 17 meters long and it took about a minute to show them. This length of 17 meters may seem odd, but it was merely governed by the capacity of the spool-boxes holding the negative film when the pictures were taken.

SADOUL: Can you mention a few titles of films which you made in 1895?

LOUIS LUMIERE: We produced a few comic films in which relations, friends, employees, etc., took part.… I should also mention the 'Landing of Members of the Congress' at Neuville-sur-Saône, which was in a way the first news film, for I took it on the occasion of the Photographic Congress in June, 1895, and showed it next day before the members of the congress.

SADOUL: Have you made any films since 1895?

LOUIS LUMIERE: Very few. I left this to the operators whom I had trained: Promio, Mesguich, Doublier, Perrigot, and others. In a few years they had entered in our catalogs over twelve hundred films made in all parts of the world.

SADOUL: How long is it since you have ceased to be interested in the cinematograph?

LOUIS LUMIERE: My last work dates back to 1935, at which time I perfected a stereoscopic cinema which was shown, in particular, at Paris, Lyons, Marseille, and Nice. However, my work has been in the direction of scientific research. I have never engaged in what is termed 'production'. I do not think I would fit into a modern studio. Moreover, I have been incapacitated for some time and can scarcely leave Bandol.

Sight and Sound
Summer 1948

The world of ideas

*The interplay of ideas
is worthy of analysis,
whether it is the impact
of a farsighted work
of fiction on an inventor
or the influence of the true-
life story of an ill-fated
device on a filmmaker.*

In The Time Machine *(1895), H. G.
Wells recounts the adventures of a man
who invents a machine that travels in
time. Some of his descriptions are fairly
cinematic: 'I think I have told you that
when I set out, before my velocity became
very high, Mrs Watchett had walked
across the room, travelling, as it seemed
to me, like a rocket. As I returned, I
passed again across that minute when
she traversed the laboratory. But now her
every motion appeared to be the exact
inversion of her previous ones. The door
at the lower end opened, and she glided
quietly up the laboratory, back foremost,
and disappeared behind the door by
which she had previously entered.'* The
Time Machine *had a profound effect on
many – and in particular on Robert W.
Paul, who referred to it and consulted the
author before preparing the following
patent application.*

A novel form of exhibition or entertainment, a means for presenting the same

My invention consists of a novel form
of exhibition whereby the spectators
have presented to their view scenes
which are supposed to occur in the
future or the past, while they are
given the sensation of voyaging upon
a machine through time, and means
for presenting these scenes
simultaneously and in conjunction with
the production of the sensations by the
mechanism described below, or its
equivalent.

The mechanism I employ consists of
a platform, or platforms, each of which
contain a suitable number of spectators
and which may be enclosed at the sides
after the spectators have taken their
places, leaving a convenient opening
towards which the latter face, and

which is directed towards a screen upon which the views are presented.

In order to create the impression of traveling, each platform may be suspended from cranks in shafts above the platform, which may be driven by an engine or other convenient source of power. These cranks may be so placed as to impart to the platform a gentle rocking motion, and may also be employed to cause the platform to travel bodily forward through a short space, when desired, or I may substitute for this portion of the mechanism similar shafts below the platforms, provided with cranks or cams, or worms keyed eccentrically on the shaft, or wheels gearing in racks attached to the underside of the platform or otherwise.

Simultaneously with the forward propulsion of the platform, I may arrange a current of air to be blown over it, either by fans attached to the sides of the platform, and intended to represent to the spectators the means of propulsion, or by a separate blower driven from the engine and arranged to throw a blast over each of the platforms.

After the starting of the mechanism, and a suitable period having elapsed, representing, say, a certain number of centuries, during which the platforms may be in darkness, or in alternations of darkness and dim light, the mechanism may be slowed and a pause made at a given epoch, on which the scene upon the screen will come gradually into view of the spectators, increasing in size and distinctness from a small vista, until the figures, etc., may appear lifelike if desired.

In order to produce a realistic effect, I prefer to use for the projection of the scene upon the screen, a number of powerful lanterns, throwing the respective portions of the picture, which may be composed of,

(1) A hypothetical landscape, containing also the representations of the inanimate objects in the scene.

(2) A slide, or slides, which may be traversed horizontally or vertically and contain representations of objects such as a navigable balloon, etc., which is required to traverse the scene.

(3) Slides or films, representing in successive instantaneous photographs, after the manner of the kinetoscope, the living persons or creatures in their natural motions....

(4) Changeable coloured, darkened, or perforated slides may be used to produce the effect on the scene of sunlight, darkness, moonlight, rain, etc.

In order to enable the scenes to be gradually enlarged to a definite amount, I may mount these lanterns on suitable carriages or trolleys, upon rails provided with stops or marks, so as to approach to or recede from the screen a definite distance, and to enable a dissolving effect to be obtained, the lantern may be fitted with the usual mechanism. In order to increase the realistic effect I may arrange that after a certain number of scenes from a hypothetical future have been presented to the spectators, they may be allowed to step from the platforms, and be conducted through grounds or buildings arranged to represent exactly one of the epochs through which the spectator is supposed to be traveling.

After the last scene is presented I prefer to arrange that the spectators should be given the sensation of voyaging backwards from the last epoch to the present, or the present epoch may be supposed to have been

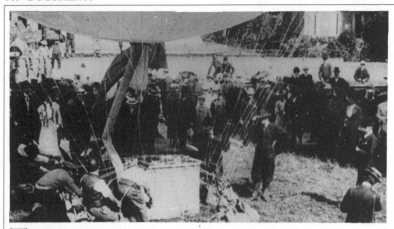

The departure of Raoul Grimoin-Sanson's balloon drew crowds in the Tuileries Gardens in Paris.

accidentally passed, and a past scene represented on the machine coming to standstill, after which the impression of traveling forward again to the present epoch may be given, and the re-arrival notified by the representation on the screen of the place at which the exhibition is held, or of some well-known building which by the movement forward of the lantern can be made to increase gradually in size as if approaching the spectator.

Robert W. Paul
British patent application no. 19984
24 October 1895

There is a curious analogy to be drawn between Raoul Grimoin-Sanson's balloon cinema and the adventures of Professor Mabouloff, the hero of one of Georges Méliès' lost films, outlined here.

Le Dirigeable Fantastique, ou le Cauchemar d'un Inventeur

Overcome by a great lassitude due to long, hard work and experiments on the problem of aerial navigation, an inventor decides to take a rest, especially since he thinks he has arrived at the perfect solution – a marvellous flying machine. He stretches out and falls asleep almost immediately. While he is sound asleep, he finds that a magic spell has been cast that covers his balloon in a net, and he helplessly watches the destruction of the plans on which he has spent his days and nights, the annihilation of his life's ambition. Little by little, he calms down. He then sees his balloon take off, with the motor running. It rises, moving easily, a total master of the air, while the clouds pass by at great speed. His overexcited mind imagines strange, indistinct forms inhabiting his balloon. These forms take the shape of women who abandon the machine to circle in the air. A comet with an incandescent tail crosses the sky. With horror, he sees it approach the balloon, which is filled with inflam-

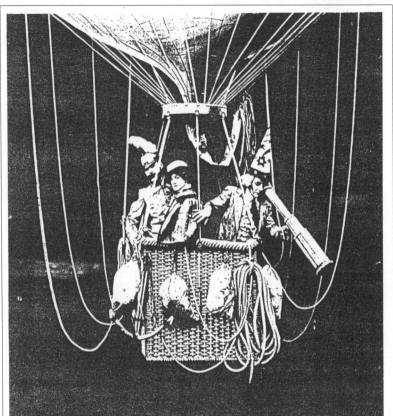

V*ers les Etoiles* (*Towards the Stars*), a 1908 film by Georges Méliès.

mable gas. The inevitable collision results, followed by an enormous explosion.

Nothing now remains of the marvellous invention which was supposed to make the name Mabouloff known to posterity. All these imaginary noises end up awakening our inventor, who finds himself in the middle of his laboratory. But the vision seemed so real to him that he is convinced that his device no longer exists. Demoralized and beaten, he throws himself out of the window. This scene is absolutely spectacular due to the ingeniousness of the remarkable strange inventions around a subject that fascinates by its possibilities and its dangers. A great film for its colour effects.

158 Scénarios de films disparus
par Georges Méliès,
1986

Tricks of the trade

Those who worked in the cinema did not like to reveal the secrets of a profession whose practices were learned by long apprenticeship. Nevertheless, in 1906, Georges Méliès agreed to write a long article in which he mixed general principles and hands-on experience. Cecil Hepworth described his ideal studio in his memoirs.

You have to lend a hand, and for a long while, in order to really understand the innumerable difficulties to be overcome in a craft that consists of doing everything, even if it seems impossible, and of giving the appearance of reality to the most fanciful dreams, the most improbable inventions of the imagination. Finally, needless to say, it is absolutely necessary to *realize the impossible*, since you are photographing it, and you must make it seen! For the special genre that concerns us here, it was necessary to create a studio prepared *ad hoc*. In a word, it was the meeting of a photographic studio (in giant proportions) and a theatre. The construction is of iron, glassed-in; at one end you find the cabin for the

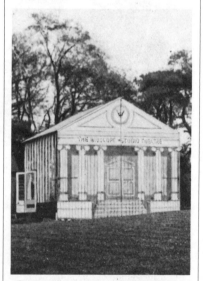

George Albert Smith's studio in Brighton, England, opened up completely so as to benefit from the daylight.

camera and operator, while at the other end a stage built exactly like those in theatres, divided like them into flaps, trapdoors and cuts in the flooring. Of course, on each side of the set there are wings, with storage rooms for sets, and behind, dressing rooms for the performers and extras. The scene includes an underground area with the trapdoors and the buffers necessary to make infernal divinities in the fairy films appear and disappear; false alleys through which the trusses are collapsed when the scene changes, and a grid overhead with drums and winches necessary for manoeuvres requiring strength (flying characters or chariots, oblique flights for angels, fairies or swimmers, etc.). Special drums serve for manoeuvring the panoramic backdrops; electric projectors light and activate apparitions. In summary, it is, in miniature, a rather faithful reproduction of a theatre for fairy stories. The stage is about ten metres wide, plus three metres of wings in the courtyard and garden. The total length, from the stage apron to the camera, is seventeen metres. Outside, there are ironwork workshops for construction of accessories, practicable scenery, etc., and a series of storerooms for construction materials, accessories and costumes.

Lighting by day and artificial light

The ceiling of the studio is partly covered with frosted glass and partly with ordinary glass. In summer, if the sun struck the sets through the glass panes, the effect would be disastrous, with the shadows of the ironwork roof showing up violently on the backdrops. Therefore, a set of mobile shutters operated by wires that can open and close them in the twinkling of an eye are used to ward off this danger. The shutters' frame is covered with tracing material used by architects to design their plans; when they are closed, this gives a softened light, similar to that of frosted glass. Regular light is extremely difficult to obtain during the execution of a scene, which can last four consecutive hours and more, for a subject that will last two to four minutes on the screen. So, during cloudy weather, when the cursed black cumulus clouds take pleasure in passing constantly in front of the sun, that friend of the photographer, exasperation is not long in manifesting itself in the person who is directing the operators, assistants, machinists, actors and extras. Endless patience is necessary: sometimes to wait until daylight wishes to return, sometimes to close the shutters if there is too much light or open them again if there is not enough, and all this without losing sight of the thousand details of the work in hand. If I am not crazy today, I will never become so, since the fleecy, cloudy or foggy skies sorely tried my patience…and caused me, during my career, countless failures, accompanied by enormous expense, since any scene begun again or impossible to play as a result of bad weather means that actors have been inconvenienced, at double, triple or quadruple the cost price, according to whether we start over two, three or four days in a row. I have seen scenes played eight consecutive days – among others, the ballet from *Faust*, which lasts two and a half minutes and cost 3,200 francs. That was something to get furious about.

In addition, after much trial and error – and although it had often been

declared impossible – I succeeded
quite recently, using a special electric
installation composed of stage lights,
trained and upright (as in the theatres)
in creating artificial lighting that gives
the absolute effect of daylight, and
which will finally spare me, in the
future, from the rude experiences of
the past. God be praised! I will not go
crazy…at least due to the clouds.…
The diffuse light is obtained with the
aid of a very large number of arc lamps
and tubes of mercury vapour suitably
combined. This artificial light is
employed concurrently with the
daylight, and the intensity can be
varied at will according to need.

Composition and preparation of scenes

The composition of a scene, whether
of a play, drama, fairy story, comedy
or an artistic scene, naturally demands
the creation of a script drawn from the
imagination; then the search for the
effects that will move the audience; the
development of sketches and models of
the sets and costumes; and the creation
of the highlighted shot, without which
no other shot has a chance of
succeeding. When one is dealing with
illusions or fairy stories, this shot, the
combination of devices, the sketches for
trick effects and the study preliminary
to their construction all demand special
care. The direction is similarly prepared
in advance, as are the movements of the
extras and the placing of the actors.
It is a task absolutely analogous to the
preparation of a stage play; with the
difference that the author must himself
know how to combine everything on
paper, and be, in consequence, the
author, director, designer and often the
actor, if he wishes to obtain a whole

that hangs together. The inventor of the
scene must direct it himself, because it
is absolutely impossible to make it
succeed if ten different people meddle.
Above all it is necessary to know exactly
what you want and throw yourself into
all the others' roles. You must not lose
sight of the fact that you cannot
rehearse for three months as in a
theatre, but for a quarter of an hour at
the most. If you waste time, the light
fails…and goodbye to the shooting.
Everything must be anticipated, even,
and especially, the pitfalls to avoid in
the course of execution – and, in scenes
done with machinery, there are many
of those.

Actors and extras

Contrary to what is generally believed,
it is very difficult to find good actors
for the cinema. One actor, excellent
in the theatre, even a star, is
absolutely useless in a film. Often even
professional mimes are bad, because
they play pantomime according to
conventional principles, just as the
ballet mimes do a special kind of
performing that is immediately
recognized. These artistes, superior
in their own speciality, are disconcerted
when they come near films.
This derives from the fact that
cinematographic gestures demand
special qualities and study in
themselves. Here there is no audience
to whom the actor speaks, whether
verbally or in mime. Only the camera is
the spectator, and nothing is worse than
watching it and worrying about it while
one is performing, which is exactly
what invariably happens the first time
to actors accustomed to the theatre and
not to the cinema. The actor must
imagine that he should make himself

understood, while remaining mute, by the 'deaf' people who are watching him. His playing must be sober, very expressive; few gestures, but very clear and precise ones. Perfect play of facial expression and very appropriate postures are indispensable. I have seen numerous scenes played by well-known actors; they were not good, because the principal element of their success, the spoken word, was lacking in the cinema. Accustomed to speaking well, they employed the gesture only as an accessory to theatrical speech, whereas in the cinema the word is nothing, the gesture everything. Some of them, nevertheless, have done good scenes, Galipaux among others. Why? Because he is used to the solo mime in his monologues, and he is gifted with the most expressive face. He knows how to make himself understood without speaking, and his gestures, even voluntarily exaggerated (which is necessary in pantomime and especially in photographed pantomime) are always most accurate. No matter how accurate an actor's gesture when it accompanies his speech, it is not at all comprehensible when he mimes. If you say 'I am thirsty' in the theatre, you will not bring your thumb with a closed hand to your mouth to simulate a bottle. It is quite useless, since the whole world has understood that you are thirsty. But, in pantomime, you would obviously be obliged to make this gesture.

It is really quite simple, isn't it? Well, nine times out of ten, this will not occur to anyone who is not used to miming. Nothing can be improvised, everything must be learned. There is need, too, for taking account of what the camera is showing. When

characters find themselves, in a shot, pressed on top of each other, you always have to pay the greatest attention to separating the principal characters off towards the front and moderating the ardour of secondary characters, who are always inclined to gesticulate inappropriately – this has the effect of producing on the screen a muddle of people fidgeting, and the audience no longer knows whom to watch and doesn't understand the action. The phases should be successive, not simultaneous. From this comes the necessity for the actors to be attentive and play their roles in turn and only at the precise moment when their participation becomes necessary. This is another thing that I have often had a hard time making actors understand, since they are always inclined to show off and be noticed, to the great detriment of the action and the whole cast; generally, they have too much goodwill. And what kid gloves you must wear to moderate this eagerness without offending them! As strange as it seems, each actor of the rather numerous troupe that I employ has been chosen from among twenty or thirty whom I tested without obtaining what was wanted, though they were all very fine artistes in the Paris theatres from which they came.…

Difficulties and drawbacks

Besides the obstacles mentioned above, that is, the difficulties inherent in the execution of these sorts of scenes, there are others that occur to hamper the cinematographer: these include the variation in light, clouds passing over the sun, accidents with the equipment, the filmstock getting stuck, the tearing of overly thin film, the emulsion's lack

of sensitivity, the spots or sparkle are found on some films after developing, which renders them unusable, in which holes imperceptible to the naked eye are transformed into sizable stones in the enlarged projection. What a relief it is after developing to realize that the shot was perfect! No layman will understand the large amounts of patience, perseverance and strong will necessary for success; and I cannot stop myself from smiling when I hear 'How come these views cost so much?' I know only too well why; but how can we make this understood by someone who does not know how this work is done and who takes away from a shot only one thing: the cheap cost of it!

Shooting: the cameraman

It goes without saying that the camera operator for this special genre must be very skilful and very informed about a host of the small tricks of the trade. A difficult view cannot be shot by a beginner. He would invariably ruin the most able accomplished effects if he forgot the smallest detail in turning the crank. One mistake in turning, forgetting one number in counting out loud while he is taking the shot, a momentary distraction – can spoil everything. It takes a calm, attentive, thoughtful man, capable of resisting all irritations and annoyances. Irritations and annoyances are almost inevitable when one is shooting, with countless difficulties and disagreeable surprises occurring almost continually.
These few observations will make it easy to understand why the shooting of fantasy scenes, depending at once on the director, the stagehands, the actors and the operator taking the scene, is so difficult. It requires total agreement,

everyone's attention, and perfect cooperation – which are scarcely easy to come by, while one is fighting against practical problems of all sorts.

This will suffice to explain why, after having thrown themselves into this new genre, most cameramen give it up. You have to be something other than a simple operator to do all this; and, while there are plenty of cameramen, those who have succeeded in making something finer than the others are few and far between: at most one per country, and yet almost all countries of the world are dependent on French manufacturers for artistic scenes.

Georges Méliès
'Les Vues cinématographiques',
Annuaire général et international de la Photographie, 1907

It was shortly after *Rescued by Rover* – and perhaps because or on account of it, for it brought considerable grist to the mill – that I began to contemplate building an indoor studio for film-making. This was in the summer of 1905. I had nothing to go upon because, so far as I knew then, or indeed, so far as I know now, there was no studio in existence and working at that time. So all the conditions had to be envisaged and the detail thrashed out in my own mind. There was no thought at all of a 'dark' studio; what I wanted was one that would let in as much as possible of the daylight while protecting us from rain and wind, but it must not cast any shadows. Ordinary window-glass would let through the maximum of light, but in sunshine there must always be the shadows of the wood or iron bars in which the glass is mounted. So I set about looking for a glass which would diffuse the sunshine and so kill the

shadows but without greatly diminishing the amount of the light. After considerable experiment I hit upon Muranese glass which exactly fulfilled these conditions. It gives beautifully smooth flood-lighting but cuts off no more light-value than ordinary glass.

But I realised, of course, that sunshine cannot be relied upon and I wanted to avoid the inconvenience of having to wait upon its vagaries. So I rigged up in our back garden – where all of this sort of thing had perforce to be done – an electric arc-lamp and tested as well as I could what additional help we might expect from this source. The result was our first studio. It was so shaped that the daylight could reach the acting floor from every reasonable point, including the space over the cameras, and, in addition, there was a row of hanging automatic arc-lamps and some more on stands which could be wheeled about into various positions.

It was some very considerable time after this that all the principal American producers abandoned New York and shifted three thousand miles across their continent to Los Angeles so as to have almost continuous sunlight, and then, as soon as they got there, dug themselves into dark studios to keep the sunlight out! I couldn't make sense of this at first but I came to realise that what they really wanted to avoid was the hourly *shifting* of the sunlight, constantly altering the values of their pre-arranged scenery. Still, they could have accomplished all that by remaining on the East side, where all actors, technicians and supplies were ready to their hands. Expense is wrought by want of thought as well as want of art.

Our studio was built at first-floor height so as to be that much above the level of surrounding houses, and the space underneath was devoted to three printing and developing machines – same old pattern – drying-rooms, mechanics' shops and so on. One small room in front between the main dark-room and the road was the perforating room with half a dozen motor-driven Debrie perforators, for it was not until considerably later that the filmstock makers took over the perforating as part of their responsibility.

It is curious to note how little faith is put by builders and folk of that sort in the ideas of people who are young and inexperienced but not necessarily silly. I designed this small building, made the plans and all necessary drawings and submitted them for an estimate to a local builder of good repute. His first response was to say, 'That roof won't work; it can't be built; it will "wind".' I didn't agree but in the end I had to make a scale model in cardboard to prove that I was right.

Then again, I had allowed a space of six feet square for a staircase turning three right-angles to the first floor. He made no comment on this but just altered the measurement to six-by-*eight* feet. But a staircase of this description, whatever its size, must be square at its base. When the building was up he found this out and had to put in an additional inner wall in accord with my measurement, and that two feet of wasted space is there to this day.

When the studio was built and ready for work I put down a sort of railway for the wheeled camera-stand to run on, to make what are now called 'tracking shots', which had not by then been heard of. Also we used a

panoramic head so as to follow the
actors as they moved about the scene,
until we were informed by America
– then our biggest customer – that
Americans would not stand these
movements and we must keep the
camera stationary. Think of American
films today when the camera is scarcely
ever still for two seconds at a time!

I don't say the Americans learned
anything from us for that is not at all
likely, but I do say that we learned a
very great deal from them, though I
for one admit that I learned too slowly.
Brought up in the stage tradition it
seemed to me for years that in all
general views you must photograph
your actors as they appear on the stage,
full length from head right down to
feet, and only in admitted close-ups
could you omit unnecessary limbs. But
the American films unblushingly cut
them off at the knees or even higher
when they could show important
details more easily that way. It looked
all wrong to me at first but I soon gave
way and adopted the new technique.
The American films which were
beginning to come over in quantities
about then, showed also far better
photographic quality, particularly in
definition, indicating much better
lenses than we were using. So we had
to hunt around for better lenses,
which soon brought us to the German
opticians and their wonderful Jena
glass.

Cecil M. Hepworth, *Came the Dawn:
Memories of a Film Pioneer*, 1951

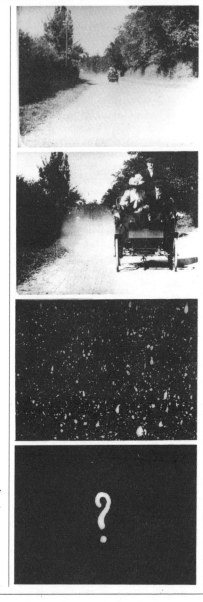

I n *How It Feels To Be Run Over* (1900)
Hepworth shows the film cameraman being
run over by a car. Notes scratched directly on
the film translate his last impressions.

The first woman filmmaker

Alice Guy started as the secretary to Léon Gaumont, who was then manufacturing cameras. The mark she made on the young film industry was much greater than either of them would ever have predicted.

As the daughter of a publisher, I had read a lot and remembered little. I had done some amateur theater and thought it could be done better. Building up my courage, I asked Gaumont if I could write one or two playlets, and to have them acted by friends of mine. Had we known what the idea would develop into, I would never have received his authorization.

Considering my age, my lack of experience, my gender, I had nothing going for me. But he did give me his permission, as long as none of this impinged upon my secretarial duties. I had to get to the office at 8 AM, open, register, and distribute the mail. I was then allowed to take the omnibus, drawn by four horses, which climbed the Buttes Chaumont via the Rue La Fayette. I could then make the most of the time allotted to me. At 4:30 PM I had to be back at St Roch to take dictation, get things signed, etc. This often took until 10 or 11 at night. Then, I could at last go home to the Quai Malaquais for a few hours' sleep, which I considered well earned.

Léon Gaumont found that I was wasting too much time with my comings and goings. He offered to fix up a small house he owned at the end of the Rue des Sonneries, behind the photography laboratory....

Sensing my hesitation, he promised to install a bathroom and to get a gardener from the Buttes Chaumont to clean up the garden. I ended up giving in. I'd been bitten by the cinema bug. Full of regret, we left our attic room on the Quai Malaquais....

I was given an unused terrace with an asphalt floor (making it impossible to fix a real set). It was covered with a shaky glass roof and overlooked an

empty lot. In this palace, I made my debut as a director. A sheet painted by a neighborhood painter who specialized primarily in scarecrows and the like; a vague set – rows of cabbage constructed by a carpenter; costumes rented around the Porte St Martin. The cast: my friends, a crying baby, a worried mother. My first film, *La Fée aux Choux* [*The Cabbage Fairy*], thus saw the light. Today it is considered a classic. The Cinémathèque Française has the negative.

I'd be going overboard if I told you it was a masterpiece, but the public wasn't blasé and the actors were young and charming. The film was enough of a success that I was allowed to try again.

Thanks to the goodwill of my small staff; thanks to the advice and lessons of Frédéric Dillaye (technical advisor to the Gaumont Corporation and the author of excellent books on art photography); thanks to the experience garnered day by day; and thanks to luck and chance – we discovered hundreds of little tricks of the trade. Here are a few of them:

Shooting the film backwards allowed houses being demolished to reconstruct themselves by pure magic; or a person falling from a roof to soar back up spontaneously; or a hungry client in a cake shop, having found the check too pricey, to return the already-eaten pastries intact.

Slowing down or speeding up the crank could turn relaxed pedestrians into frenetic madmen or sleepwalkers.

Stopping the film allowed us to move an object which, during projection, seemed endowed with supernatural powers: an archaeologist could thus be stupefied to find his precious mummy playing in the four corners of his laboratory. Example: *The Mummy*.

Shooting from different distances made it possible to place in the same frame both pygmies and giants, as in *Lilliput and Gulliver*, *The Ogre and Tom Thumb*, and *The Grandfather Clock's Cakewalk*.

Double exposures.

Dissolves used for visions and dreams.

We also made some movies on location. During a walk in Barbizon, we came across an old stagecoach. I decided to direct *The Mail from Lyons*. A theatrical troupe would have been too expensive, so I persuaded my staff to play the parts. Armed with a copious homemade lunch, costumes, props and a bicycle for almost everyone, we took the train to Melun. At the station, two or three cars, with drivers claiming to be guides to the Fontainebleau forest, took the less athletic young women and the packages. We all set off for Barbizon, where the stagecoach was awaiting us.

The guides took us to a place they considered appropriate. After having savored our picnic, we handed out the costumes. The women did their best behind bushes. The men, less prim, got dressed anywhere. Fortunately, the forest was empty, because we must have been quite a strange sight.…

Despite the brisk autumn weather, our venture was a success. We were full of joy and good humor, and we decided to do it again.

All these short films (of 17 to 25 meters), shot in incredible circumstances, contained the seeds of today's cinema.

Alice Guy
Autobiography of a Film Pioneer
(1873–1968), 1976

War films

Camera operators assigned to film the great international conflicts led a life only slightly less dangerous than the combatants and sometimes even took part in the engagements.

In 1898 Billy Bitzer was sent to Cuba to cover the Spanish-American War – his first – with a particularly awkward Biograph camera

The Biograph movie camera was out after scoops called 'News Happenings', when word came that the U.S. Navy battleship *Maine* had been blown up in Havana Harbor, so I was sent with my cumbersome camera to cover the story.

I embarked upon the *Seguranca*, reaching Havana on February 19, 1898, four days after the news broke. On Wednesday morning we sighted in the distance old Morro Castle, a sheer two hundred feet [sixty metres] above the sea. To the left of Morro was La Sohaca, and ahead stretched a winding waterway bordered by palm-fringed shores. At the entrance to the bay we passed Estrella Point and Cayo

A cameraman from the Charles Urban Trading Company with a Bioscope.

The sailors of the *Potemkin* led a workers' uprising in Odessa in 1905. The story quickly became the subject of a Pathé reconstruction in *La Revolution en Russie* of the same year.

Smith, a picturesque, hilly islet. It was then we came abreast of the battleship *Maine*, an unrecognizable mass of scrap iron, twisted and mangled. Only a single hulk remained, from which flew the American flag, in what appeared defiance of those who had destroyed her.

Visiting Cuba under Spanish rule was highly dangerous. With bag and baggage we were hustled into the Customs House. My camera was bulky enough, but when you consider it was driven by a motor operated by over two thousand pounds of storage batteries, packed in many boxes, which the officials insisted on examining, all this took much time. The grins and leers on the faces of bystanders gave me to

understand this was unfriendly territory. Luckily I had been warned beforehand to go straight to the Ingleterra Hotel, where I would find comfort and safety. As I learned later, it was well for me that I was one to follow orders. After checking in at the hotel, I went back to the wreckage of the *Maine* to take pictures.

Divers were at work recovering bodies – at one end Spanish divers, and at the other Americans. I knew it would be impossible for me, with my bulky camera, to get pictures that would tell the true story, but our boys with still cameras did such admirable work that today in the photo section of the Library of Congress you are able to see it for yourself. All I got was moving

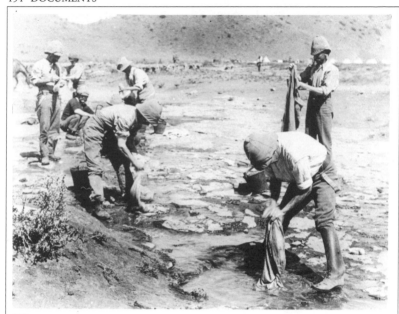

During the Boer War, the soldiers' life was captured by the lens of Joseph Rosenthal.

pictures of the *Maine* as seen from the shore.

I remained in Havana, trying to get pictures from a towboat, and then we were ordered back to New York on the same day Ambassador Fitzhugh Lee evacuated Havana. In New York they kept me busy on 'News Happenings', and it was not until April 21 (my twenty-sixth birthday, incidentally) that I returned, as war was then declared by the United States.

I happened to be in Boston covering more news when the Biograph office telegraphed that arrangements had been made with the New York *Journal* for several newsmen, two still photographers, and myself with the movie outfit to go aboard a towboat to cover the war in Cuba. This time my journey took me to Siboney, the point where our battleships had cleared out the Spanish to make a landing for our troops. I took some shots of the troops landing from the 'Yale' and 'Harvard' transports, and other shots along the beach.

I found myself helpless to advance with the troops because of the scarcity of horses. Horses had been shipped all right, but most of them had drowned. The horses had simply been pushed overboard without anyone holding up their heads, and the weight of a horse in rough water was too much. They had drowned because no one there knew how to handle the situation before it got out of hand.

Those in charge of the landing had been greatly at fault.

Without means of transportation to follow the troops, I returned to my towboat, where we stationed ourselves, taking pictures each morning as the battleships in Havana harbor fired on the sand batteries about Morro Castle. Through binoculars we could see the clouds of sand and what seemed to be bodies of men and fragments of guns flying in the air toward us. At this point we were ordered out to sea, with threats of arrest if we came in line of the battleship fire again. We stationed ourselves three miles [nearly five kilometres] out, in international waters, awaiting a reprieve. I was relieved by this, remembering a near-miss shell that struck the water just a little in front of us and ricocheted over my head. I had pulled the focusing cloth I was using just a little further over my head, like a damn fool, but continued grinding out the action nevertheless.

We remained on the towboat waiting for the big naval battle that was rumored. We were growing impatient when one morning a crew man shook us awake: 'Your big boss is outside, it's time to get up.' Then I saw the yacht *Sylvia* standing across the water, so we were taken over to her. Aboard was William Randolph Hearst of the New York *Journal*, accompanied by Jack Follansbee, James Creelman, and two pretty young ladies who were sisters. It looked mighty inviting after all the tedious hours we had spent.

Here were champagne and lively companionship. One still-cameraman of our party needed ice in developing his plates, and here we had plenty of ice. This change from the smell of tar

rope and oil and the confined quarters of the towboat was the best remedy we could have to relieve tension and refresh our spirits.

The *Sylvia* had just arrived that morning, and they were all anxious to go sightseeing. This would be difficult if the girls were seen by the sailors on the battleships, so to prevent this, the girls donned male attire. We were in the delirious state of being under fire in war time, and we got more friendly than we would have at home; the crew mixed with the guests and vice versa.

Having discovered that the Spanish fleet was lying at anchor in Havana harbor, our fleet, the North American Squadron, promptly bottled their exit by sinking the *Merrimac* across the entrance of the harbor. I could not get pictures, as this took place at night.

I decided at this juncture to land with my Frankenstein-like camera and exert new efforts to obtain battle scenes. Frederic Remington, who was returning to the States, gave me his horse to view the prospects and pull the camera ashore. Then I was ready to follow the troops inland. The outposts were within a few miles of Havana, so I started with my camera toward General William R. Shafter's headquarters, halfway between my starting point and the front line.

I took movies of the general with his staff, crossing a stream on horseback. He was a portly gentleman and filled the area of the postal-card movie field so well that it was unnecessary to worry about filling in the background.

G. W. Bitzer
Billy Bitzer: His Story
1973

The birth of the advertising film

The first advertising films appeared, projected on screens in the open air, in New York in 1897 and Paris in 1898. Edwin Porter, Félix Mesguich and Georges Méliès claim the paternity of this ingenious idea.

In the spring of 1897 Edwin S. Porter... found something that was truly new. Kuhn & Webster, from whom he had bought his Projectorscope and West Indian rights, were engaged in making the first advertising films. Porter was employed to handle the projection of these pictures on a screen billboard facing Broadway at Thirty-fourth street, Herald Square. The pictures were made for a Scotchman who conceived the idea and owned the venture. Although his name has been lost to memory, the merit of his advertising lingers in the recollection that his first account was the bonny, brave Haig & Haig highland whiskey....

From nightfall until midnight Porter ground off the advertising films from a little coop on the top of the Pepper Building. The advertising was interlarded with short bits of current subjects and the brief topical snatches of the day. The machine was behind the screen, a large translucent fabric sheet....

The exhibitors of motion pictures in the adjacent amusement houses were also displeased with this public broadcasting of their medium of profit. Somebody said a word at the Tenderloin police station.

A few nights went by and then Porter, looking out from his projection coop, in the midst of a showing, saw Inspector Chapman, the hero of the Seeley dinner raid, in all the glory of his side whiskers, coming stealthily over the roof, accompanied by a uniformed squad.

Porter was arrested on a charge of blocking traffic and marched to court. That was the end of the venture, the first showing of advertising films.

Terry Ramsaye,
A Million and One Nights: A History of the Motion Picture, 1926

Méliès played on the disproportion between objects and people for the purposes of advertising.

A vast advertising billboard was spread out on the third floor of a building on Boulevard Montmartre. A swivelling frame reproduced photographs as in a magic lantern. Pedestrians were scarcely interested in it and passed it by. It was, in my opinion, fruitless. I suddenly imagined that if it became animated, it would arouse the curiosity of Parisians much more.

The next day, I explained this concept to Mr Vergnes, director of the agency, and having convinced him, I quickly left for Lyons to buy a variety of Lumière equipment, a camera and a projector. It was on 18 October 1898 that a luminous advertisement by

means of cinema appeared for the first time, at 5 Boulevard Montmartre. Thereafter, many animated posters followed each other on that screen, starting with the one for 'Ripolin'.

I had got it right; from the first day, all the passersby raised their heads, the double-decker bus 'Madeleine-Bastille' was immobilized and vehicles came to a stop. A new creation was sufficient to conquer central Paris. Regulations should be made to prevent bottlenecks on the grand boulevards.

Then came the turn of the Compagnie des Wagons-Lits, which was promoting travel for tourists through its photos, very well chosen

moreover, of the Pyrenees, Savoy and the Côte d'Azur. A report of my proposals was sent by the company to the railway companies; it simply involved taking panoramas of landscapes as they appeared from the doorway of a moving train.

The response of the Compagnie du P.L.M. reached me a week later, accompanied by a circular letter to agents of the network and a travel permit. I got the same facilities on the lines in the Midi. They authorized me to harness a special wagon to the front of the locomotive. Thanks to a very simple arrangement adapted to my platform, the solidly fixed camera stuck out through an open window.

I began with the Côte d'Azur. Leaning over the viewfinder, I saw the coast flash past at great speed. With their sudden changes, the rapid and rushing views look like coloured images. I scarcely had time to admire the site when Saint-Raphael flew by under a dazzling sky. The locomotive galloped along, roared between the pines and crimson rocks of Trayas, and crossed the Estérel. After countless curves, it emerged at Cannes in the perfume of mimosas; the eye rested on the sea where the waves broke on the Croisette and the islets of Sainte-Marguerite and Saint-Honorat; then, in the rosy distance, the Cap d'Antibes grew blurry and disappeared.

When, in front of the locomotive, my carriage surged into the hurly-burly of the Nice station, I had the illusion of conducting the train. On the platforms, the passengers looked at me curiously, as if they suspected me of experimenting with a new mode of traction....

Thus at the beginning of the year 1899, the open-air screen of the Compagnie des Wagons-Lits in the Place de l'Opéra reflected the lively face of some corners of French soil.

Félix Mesguich
Tours de manivelle, 1933

The year 1898 did not close without Méliès having a new stroke of genius. Coming home one day, he said to Eugénie: 'What a marvellous vehicle of propaganda the cinema is for the sale of all sorts of products! An original idea would be enough to attract the public's attention, and, in the middle of the film, you could drop the name of the chosen product…' The advertising film had just been born!

A few days later, in fact, Méliès shot the first of such films. He installed on the balcony of the mezzanine of the Robert-Houdin Théâtre, just above the entrance door, a giant screen on which he projected, transparently, from his office, comic sketches that particularly attracted the public, since their screening was free. In general, the advertising message did not appear until the end of the scenario, once the audience was caught up in the action. Naturally, the films were paid for by the firms concerned.

Méliès immediately had more clients than he wanted. Thus, for example, he shot for the famous Bornibus mustard a scene in which he gave his imagination free rein, because even in advertising films, he remained the great Méliès. For Bornibus, he imagined a restaurant in which the clients argued and sprayed each other with mustard. Soon, the ground is strewn with mustard pots. You have to believe the mustard is tasty when a dog starts to lick it greedily.

'To get a dog to lick a pot of mustard,' Méliès recounted, 'was not

M éliès' advertisement for Bornibus mustard, with the dog nowhere in sight.

easy. So I resorted to a trick: I replaced the mustard with chocolate cream, which justified the keenness of the good doggie.... After which appears Bornibus' slogan: "Bornibus mustard and pickles, made as Mother Marianne would." '

The impact on those who sauntered along the Boulevard des Italiens was considerable. For each new client Méliès had an original idea. He sang the praises of many celebrated products of the era: Orbec beer, Picon apéritif, Delion hats, Menier chocolate, Widow Brunot's wax, John Dewar's whiskey and many others. Naturally, in these films, as in his other productions, Georges Méliès used the already rather abundant form of the in-house star, Jehanne d'Alcy. Jehanne later remembered:

'I had done the Bornibus mustard, the Poulain chocolate. We were given a corset and twenty francs. A man had come along who had invented a so-called whalebone stiffener which was better than the usual corset whalebone and was less expensive. So there we were in pantaloons, with a corset. There was also a film on a product to make hair grow again. The actor, instead of putting the product on his head, poured it over his feet and he grew hair on his shoes.'

Madeleine Malthête-Méliès
Méliès, the Enchanter, 1985

Eroticism in the cinema

Some of the very first films were often on such subjects as 'the bride goes to bed', inspired by a postcard series. By the turn of the century, erotic films constituted a formal and expected category in production company catalogues. This list is taken from the Pathé catalogue of the time.

Saucy titillating scenes

(Do not admit children to the exhibition of these scenes.)

770 – *The awakening of Chrysis*
(20 metres)
In an atmosphere of perfumes from the Orient, Chrysis awakens. A Negress lavishes her with care, while Chrysis languorously raises herself from her bed, her body still languid from sleep.

772—*The judgment of Phryné*
(20 metres)
In the attack by an Arab sheik on a caravan, a beautiful young woman has been captured. She is brought before the sheik, who immediately summons his eunuchs, asking them if the new arrival is worthy of the harem. On their affirmative reply and after careful examination, the captive is admitted and led to the women's dwelling.

775 – *Yvette and Pierreuse going to bed*
(20 metres)
The scene shows two very different bedrooms. On the left, a prostitute, whom a procurer mistreats, goes to bed, half-dressed, in a sort of cubbyhole; while on the right we see a richly furnished room, occupied by a pretty person who puts herself to bed.

776 – *Yvette and Pierreuse getting up*
(20 metres)
Same decor as the preceding scene. This one shows a half-dressed suitor kissing Yvette; she wakes up and stretches at great length; the servant brings breakfast. Meanwhile, in her hovel Pierreuse puts on her rags. The procurer has already emptied her pockets.

The music hall actress Louise Willy in *Le Coucher de la Mariée* (*The Bride Goes to Bed*), a postcard series reshot for the cinema.

777 – *Adultery 'in flagrante delicto'*
(15 metres)
The woman comes to a rendezvous, and she is surprised there by her husband, the police superintendent and his agents. The officer discovers the woman naked in the bathroom, and the furious lover throws himself on the husband, but is held back by the police. (*Reproduction of a famous painting by Garnier.*)

778 – *Socialite in the bath*
(20 metres)
A pretty woman in a bathroom removes her clothing to climb into the bathtub. The servant comes in to help her.

780 – *'L'Assommoir' by Emile Zola – the laundry scene* (15 metres)
To our great satisfaction, we have been able to render the famous scene offered us by the celebrated realist novelist in *L'Assommoir* in an even more lifelike manner.

781 – *Painter and model (undressed)*
(20 metres)
A painter and a model who feels disgust at getting undressed. The painter manages to convince her and touches her suggestively.

782 – *Facetious painter* (20 metres)
In his studio, a painter who is a real joker has a pretty woman sit for him; she thumbs her nose at him each time he turns his back. The painter shows his subject the canvas, on which he has drawn a cow. The furious woman breaks the canvas over his head.

783 – *The flea* (20 metres)
A pretty young person in a negligee is looking for a flea. A play of expressions and poses that is totally suggestive.

CHRONOLOGY

16th century
Painters and engravers use a camera obscura
investigated by Leonardo da Vinci
(It., 1452–1519)

1646
The Jesuit scholar Athanasius Kircher (Ger.,
1601–80) describes a magic lantern in
Ars Magna Lucis et Umbrae

1798
Etienne Gaspar Robert, known as Robertson
(Belg., 1763–1837), presents his first
Phantasmagoria shows using an enhanced magic
lantern

1826
Joseph Nicéphore Niepce (Fr., 1765–1833) takes
the first still photograph using a kind of camera
obscura
The Thaumatrope, devised by Dr John Ayrton
Paris (GB), blurs the images on two sides of a
round card into a single image when spun by an
attached string

1829
Joseph Plateau (Belg., 1801–83) first writes about
the phenomenon of persistence of vision

1833
Plateau invents the Phenakistoscope, a slotted disk
that resynthesizes continuous motion

1834
The mathematician William George Horner
(GB, 1786–1837) devises the Daedelum
(renamed Zoetrope), a bowl-shaped version of the
Phenakistoscope

1837
Louis-Jacques-Mandé Daguerre (Fr., 1789–1851)
invents the daguerreotype, which fixes images on
a silver-covered copper plate

1839
Henry Langdon Childe (GB) introduces
dissolving views, an enhanced magic
lantern effect

1853
Baron Franz von Uchatius (Aus.) projects images
on to a screen by combining a phenakistoscopic
disk with a magic lantern

1864
Louis Arthur Ducos de Haron (Fr., 1837–1920)
patents (but never builds) a 3600-lens camera
designed to record successive images

1873
Eadweard James Muybridge (GB, 1830–1904)
contrives a photographic apparatus
to analyse the motion of a trotting horse

1874
Astronomer Pierre-Jules-Cesar Janssen
(Fr., 1824–1907) devises a photographic
mechanism to record the transit of Venus across
the sun

1877
Emile Reynaud (Fr., 1844–1918) invents the
Praxinoscope, an improved Zoetrope
Muybridge publishes his sequences of stop-action
photographs of horses, taken by setting up a
battery of twelve (later expanded to twenty-four,
then forty-eight) cameras

1878
Thomas Alva Edison (US, 1847–1931) invents
the phonograph

1879
Photographers use gelatin plates sensitized with
bromide of silver
Ferrier works on roll film and coats a flexible gelatin
strip with a gelatin-bromide emulsion
Muybridge's Zoogyroscope (an improved
Zoetrope) reconstitutes motion captured by his
stop-action photographs

1880
Reynaud invents the projecting Praxinoscope

1881
Muybridge creates the Zoopraxiscope, a refined
Zoogyroscope
Louis Lumière (Fr., 1864–1948) perfects his blue
label photographic plate

1882
Etienne-Jules Marey (Fr., 1830–1904) devises a
photographic gun to record sequential images
and invents a fixed-plate chronophotographic
camera

1883
Albert Londe (Fr., 1858–1917) uses his multiple-
lens camera at the Hôpital de la Salpêtrière

1886

Louis Aimé Augustin Le Prince (Fr., 1841–90) patents a multiple-lens camera using paper filmstrips

1887

Hannibal Goodwin (US) invents flexible cellulose nitrate-based roll film
Marey invents a chronophotograph that uses paper roll film
Muybridge publishes *Animal Locomotion (Animals in Motion, The Human Figure in Motion)*
Ottomar Anschütz (Ger., 1846–1907) presents his Electrotachyscope to Berlin audiences

1888

Edison and William Kennedy Laurie Dickson (US, 1860–1937) build an optical cylindrical phonograph
Reynaud patents his Théâtre Optique

1889

George Eastman (US, 1854–1932) develops and markets flexible cellulose nitrate roll film
Edison and Dickson order batches of film from Eastman and perforate the strips
William Friese-Greene (GB, 1855–1921) records animated photographs with a chronophotographic camera

1891

Georges Démeny (Fr., 1850–1917) invents the Phonoscope, designed to resynthesize lip movement for deaf-mutes
Edison and Dickson patent a motion-picture camera (Kinetograph) and an individual viewing machine (Kinetoscope)

1892

Edison, Dickson, and Eugène Lauste (Fr., 1856–1935) work on the Kinetophone, an early combination kinetoscope and phonograph
Léon Bouly (Fr., 1872–1932) patents the Cinématographe, a camera that both analyses and resynthesizes motion
Reynaud presents his Théâtre Optique and projects his 'Luminous Pantomimes' at the Musée Grévin, Paris

1893

Acme LeRoy (US, 1854–1944) and Lauste invent the Marvelous Cinematograph, a Kinetoscope projector
Démeny builds a Chronophotograph with a cam mechanism
Edison's Black Maria, the world's first motion-picture studio, is built
Kinetoscope Company founded by Norman Raff and Frank Gammon

1894

Dickson shoots his first films for Kinetoscope
Opening of the first Kinetoscope parlors in New York and London
First demonstration of LeRoy and Lauste's Marvelous Cinematograph projector in New York
Working with Woodville Latham (US, 1838–1911) and his sons Gray and Otway, Lauste invents the Panoptikon (renamed Eidoloscope), a new type of Kinetoscope projector
Woodville Latham invents the so-called Latham loop, a small loop of excess film, which prevents tearing
Max Skladanowsky (Ger., 1863–1939) builds his Bioskop and shoots short scenes
Charles Pathé (Fr., 1863–1957) exhibits Edison phonographs at fairgrounds
Louis Lumière invents a new feed mechanism; his chief engineer, Charles Moisson, is asked to build the prototype of a machine to shoot, print and project moving pictures

1895

Lumière patents the Cinématographe
Lumière shoots *La Sortie d'Usine* and other films
First private demonstrations of Lumière's Cinématographe
Robert W. Paul (GB, 1869–1943) builds counterfeit Kinetoscopes. Working with Birt Acres (GB, 1854–1918), he develops the Animatograph (or Theatrograph) camera and shoots his first films
Pathé exhibits counterfeit Kinetoscopes purchased from Paul
Pathé teams up with Henri Joly (Fr., 1866–1945), who builds a multipeephole Kinetoscope and a camera
Thomas Armat (US, 1866–1948) and Charles Francis Jenkins (US, 1867–1934) invent the Phantascope, a Kinetoscope projector
Edison gains control of the Armat patents and markets the projector as the Vitascope
First public performance of Skladanowsky's Bioskop projector at the Wintergarden, Berlin
Dickson, Herman Casler, Harry Marvin and Elias Bernard Koopman form the American Mutoscope Company
The Mutoscope is built
The Cinématographe Lumière opens to the public in the Salon Indien of the Grand Café, Paris

1896

Lumière's Cinématographe filming worldwide
Paul's Theatrograph debuts at the Egyptian Hall, London

First Vitascope screening for a paying audience at Koster & Bial's Music Hall, New York
Jules Carpenter builds a series of Lumière cinematographs
Auguste Baron (Fr., 1855–1938) invents a process for making sound pictures
Pathé Frères founded by Charles Pathé and brothers Emile, Jacques and Théophile
Léon Gaumont (Fr., 1864–1946) comes out with his 60-mm Démeny Chronophotographe
Biograph camera built
Screening of first Biograph films
Georges Méliès (Fr., 1861–1938) shoots his first films, including *Escamotage d'une Dame chez Robert-Houdin*

1897
A 60-mm Joly-Normandin projector causes a fire, killing 140
Méliès builds a studio at Montreuil-sous-Bois
Gaumont brings out his 35-mm Gaumont-Démeny Chronophotographe
Gaumont's secretary, Alice Guy (Fr., 1873–1968), shoots her first films
J. Stuart Blackton (US, 1875–1941) and Albert E. Smith found the Vitagraph Company
Paul forms Paul's Animatograph Works, Ltd
George Albert Smith (GB, 1864–1959) and James A. Williamson (GB, 1855–1933) shoot their first films in Brighton

1898
Edison fires the opening shots in the 'War of the Patents'
Charles Urban (US, 1871–1942) forms the Warwick Trading Company in London
The battleship *Maine* is blown up in Havana harbour, triggering the Spanish-American War and inspiring the first historical reconstruction films
Multiple-shot films by Méliès and Paul introduced

1899
Méliès' *L'Affaire Dreyfus*
Newsreel-type films of action, both live and reenacted, shot of Transvaal during the Boer War

1900
Eighteen film-projection attractions at the Paris Universal Exposition include Lumière's giant-screen Cinématographe, the Cinéorama of Raoul Grimoin-Sanson (Fr., 1860–1941), the Phonorama and the Phono-Cinema-Théâtre

Smith's *Grandma's Reading Glass*
Williamson's *Attack on a China Mission Station*

1901
Williamson's *The Big Swallow* and *Stop Thief!*
L'Histoire d'un Crime by Ferdinand Zecca (Fr., 1864–1947)

1902
Pathé Studios built at Vincennes
Gaumont demonstrates his Phonoscènes (talking films) to the Société Française de Photographie
Méliès' *Le Voyage dans la Lune*
Méliès' *Le Sacre d'Edouard VII*
Zecca's *Les Victimes d'Alcoolisme*
Urban forms the Charles Urban Trading Company
The Life of an American Fireman by Edwin S. Porter (US, 1870–1941)

1903
Porter's *The Great Train Robbery*

1904
Hale's Tours opens at the St Louis World's Fair
Newsreel-type films of action, both live and reconstructed, during the Russo-Japanese War
Chase films increasingly popular

1905
Stencil colouring of films begins
Gaumont studios built in Paris
Rescued by Rover by Cecil Hepworth (GB, 1873–1953)
First Italian fiction film, *La Presa di Roma*, by Filoteo Alberini (It., 1865–1937)

1906
Smith patents Kinemacolor, a two-colour filmmaking process
Oskar Messter (Ger., 1866–1943) develops a system for making sound films
Development of Gaumont's Chronophone
The Vitagraph Company of America opens a new studio in Brooklyn; the American Mutoscope and Biograph Company opens a West Coast office in Los Angeles
Nickelodeons spring up across the United States
Formation of Cinés film company in Italy and Nordisk Films Compagni in Denmark
Blackton's *Humorous Phases of Funny Faces*
Méliès' *Les Quatre Cents Farces du Diable*
Alice Guy's *La Vie de Christ*

FURTHER READING

Abel, Richard, *The Ciné Goes to Town: French Cinema, 1864–1914*, 1994

Bandy, Mary Lea, ed., *Rediscovering French Film*, 1983

Barnes, John, *The Beginnings of the Cinema in England*, 1976

Bitzer, G. W., *Billy Bitzer: His Story*, 1973

Blaché, Alice Guy, *The Memoirs of Alice Guy Blaché*, trans. Roberta and Simone Blaché, ed. Anthony Slide, 1986

Burch, Noël, *Life to Those Shadows*, trans. and ed. by Ben Brewster, 1990

Chanan, Michael, *The Dream That Kicks: The Prehistory and Early Years of Cinema in Britain*, 1980

Cinema 1900–1906: An Analytical Study, 2 vols., 1982

Crafton, Donald, *Before Mickey: The Animated Film 1898–1928*, 1982

Elsaesser, Thomas, with Adam Barker, eds., *Early Cinema: Space – Frame – Narrative*, 1990

Fell, John L., et al., *Before Hollywood: Turn-of-the Century American Film*, 1987

Frazer, John, *Artificially Arranged Scenes: The Films of Georges Méliès*, 1979

Garçon, François, *Gaumont: A Century of French Cinema*, 1994

Gomery, Douglas, *Shared Pleasures: A History of Movie Presentation in the United States*, 1992

Hammond, Paul, *Marvelous Méliès*, 1974

Hepworth, Cecil M., *Came the Dawn: Memories of a Film Pioneer*, 1951

Low, Rachel and R. Manvell, eds., *The History of the British Film*, vol. I: 1896–1906, 1948

Malthête-Méliès, Madeleine, *Méliès l'Enchanteur*, 1985

Mast, Gerald, *A Short History of the Movies*, 1985

Michelson, Annette, et al., *The Art of Moving Shadows*, 1989

Musser, Charles, *Before the Nickelodeon: Edwin S. Porter and the Edison Manufacturing Company*, 1991

—, *The Emergence of Cinema: The American Screen to 1907*, 1990

158 Scénarios de Films Disparus de Georges Méliès, 1985

Ramsaye, Terry, *A Million and One Nights: A History of the Motion Picture*, 1926

Rawlence, Christopher, *The Missing Reel: The Untold Story of the Lost Inventor of Moving Pictures*, 1991

Salt, Barry, *Film Style and Technology: History and Analysis*, 1992

Sklar, Robert, *Film: An International History of the Medium*, 1993

FILM LIBRARIES AND MUSEUMS

In 1938 representatives of the Museum of Modern Art in New York, the National Archives in London, the film archives of the German Reich in Berlin and the Cinémathèque Française in Paris met with an important goal. They wanted to join forces to help fight a battle each was already waging independently: to promote, exhibit and conserve the cinema, in particular, silent films, which at the time were considered to be lacking in both commercial and artistic value – the recently developed talking films were overwhelmingly popular. The four were convinced that film has an artistic and aesthetic importance in addition to its historical and social value, and that it gives us important information about our past as well as our future. Together, they formed the International Federation of Film Archives (FIAF), which, based in Brussels, has many members around the world who share in common programmes.

FILM LIBRARIES

The first films in the history of the cinema are conserved by specialized archives and cinematheques (film libraries), national institutions, private associations and private collectors. A great number of films have nevertheless disappeared, and the safeguarding of those that remain is problematic, since they were recorded on nitrate cellulose filmstock, which is inflammable and chemically unstable. The major collections include:

CANADA
Cinémathèque Québecoise, 335 Boulevard de Maisonneuve, Montreal, Quebec H2X 1K1

ENGLAND
The Imperial War Museum, Department of Film, Lambeth Road, London SE1 6HZ

National Film Archive, British Film Institute, 21 Stephen Street, London W1P 1PL

FRANCE
Cinémathèque Française, Palais de Chaillot, Avenue Albert-de-Mun, 75016 Paris
Includes a museum and libraries of stills and books
Service des Archives du Film du Centre National de la Cinématographie, 7 bis rue Alexandre-Turpault, 78390 Bois-d'Arcy
Includes a collection of equipment and posters

UNITED STATES
Library of Congress, Motion Picture, Broadcasting, and Recorded Sound Division Washington, DC 20540
Includes collection of paper prints of films that producers deposited to serve as copyright and to prevent counterfeiting
Museum of Modern Art, Department of Film, 11 West 53 Street, New York, NY 10019
National Center for Film and Video Preservation, American Film Institute, P.O. Box 27999, 2021 North Western Avenue Los Angeles, CA 90027
Pacific Film Archive, University Art Museum, 2625 Durant Avenue, Berkeley, CA 94720

FILM MUSEUMS

ENGLAND
The Museum of the Moving Image, South Bank, London SE1 8ST
National Museum of Photography, Film and Television, Pictureville, Bradford, West Yorkshire BD1 1NQ

FRANCE
Musée Henri-Langlois, Cinémathèque Française, Palais de Chaillot, Avenue Albert-de-Mun, 75016 Paris
Musée d'Orsay, 1 rue de Bellechasse, 75007 Paris

ITALY
Museo Nazionale del Cinema, Palazzo Chiablese, Piazza San Giovanni 2, 10122 Turin

UNITED STATES
American Museum of the Moving Image, 3601 35th Avenue, Astoria, NY 11106

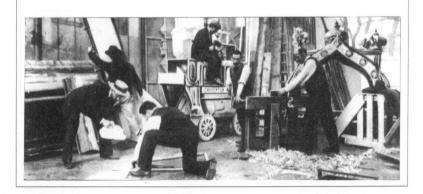

LIST OF ILLUSTRATIONS

The following abbreviations have been used:
a above; *b* below; *c* centre; *l* left; *r* right;
BFI British Film Institute, London; CF
Cinémathèque Française, Paris; CNAMP
Conservatoire National des Arts et Métiers, Paris;
MNATP Musée National des Arts et Traditions
Populaires, Paris; MOMA Museum of Modern
Art, Film Stills Archive, New York.

Names in parentheses refer to studios.

COVER

Front Edwin S. Porter, *The Great Train Robbery*
(Edison, 1903). BFI; Institut Jean–Vigo,
Perpignan; Cinemathèque Universitaire, Paris
Back Grimoin–Sanson's projector and slide
viewer, 1902. Coll. Gianati

OPENING

1–9 Edwin S. Porter, *The Great Train Robbery*
(Edison, 1903). BFI; Institut Jean–Vigo,
Perpignan; Cinemathèque Universitaire, Paris
11 Abel Truchet. Lithograph

CHAPTER 1

12 Henri Brispot. Poster for the
Cinématographe Lumière, 1896. CF
13 Louis Lumière, *Bataille de Femmes/Battle
of the Women*. CF
14a Louis Auzolle. Poster for the
Cinématographe Lumière, 1896. CF
14b Jules Chéret (attrib.). Cinématographe.
Watercolour, 1896. Museo Nazionale del
Cinema, Turin
15 The Grand Café, Boulevard des Capucines,
Paris. Photograph. CF
16 Louis Lumière, *L'Arrivée d'un Train en
Gare/The Arrival of a Train at a Station*, 1896. CF
17a Poster announcing a Cinématographe
Lumière programme in Lyons, 1898. Institut
Lumière, Lyons
17b Louis Lumière, *Leçon de Bicyclette/Bicycle
Lesson*, 1895. CF
18 The Empire Theatre, Leicester Square,
London. Photograph. Coll. Will Day, CF
19a English poster for the Lumières'
Cinématographe
19b Louis Lumière, *La Partie d'Ecarté/The Card
Game*, 1895. CF
20–1 *Parade de Sport/Sports Exhibition*
(Lumière). CF

21 *Chicago: La Grande Roue/Chicago: The Big
Ferris Wheel* (Lumière). CF
22 B. Naudin. Félix Mesguich. Drawing in Félix
Mesguich, *Tours de Manivelle/Cranking the
Camera*, 1933
22–3 Charles Moisson and Francis Doublier, *Le
Couronnement de Tsar/The Coronation of the Czar*
(Lumière, 1896). CF
24 Russian poster announcing a
Cinématographe Lumière programme, 1899.
Institut Lumière, Lyons
24–5 *Rue de Chine/Chinese Street* (Lumière). CF
25 Italian poster announcing a Cinématographe
Lumière programme. Museo Nazionale del
Cinema, Turin

CHAPTER 2

26 *La Danse du Diable/The Dance of the Devil*
(Pathé, c. 1904). BFI
27 Antoine Lumière with his photographic
equipment. Photograph, c. 1870. Institut
Lumière, Lyons
28l Deaf-mute using a Phonoscope. Print in *La
Nature*, 16 April 1892
28r Phonoscope. Engraving in *La Nature*, 16
April 1892
28–9 Albert Londe. Photochronographic print.
Engraving in *La Nature*, 11 November 1893
29 Demonstration of Ottomar Anschütz's
Electrotachyscope. Print in *La Nature*, 1889
30–1 Plates 263 and 739 in Eadweard
Muybridge, *Animal Locomotion*, 1887
31 Eadweard Muybridge. Print in *The Illustrated
London News*, 25 May 1889
32 Etienne-Jules Marey. Chronophotographe
of man jumping off a springboard. CF
32–3 Etienne-Jules Marey. Chronophotographe
of a walking man. CF
33a Marey's photographic gun. Engraving in
La Nature, 22 April 1882
33b Etienne-Jules Marey. Photograph. Coll.
Will Day, CF
34a Thomas Alva Edison. Photograph. Coll.
Will Day, CF
34b Edison's Kinetoscope. Engraving in *La
Nature*, 20 October 1894
35l William Kennedy Laurie Dickson and
Etienne-Jules Marey at the 1900 World Fair,
Paris. Photograph. MOMA
35r *Fred Ott's Sneeze* (Edison, 1894). MOMA
36–7 The Black Maria. Photograph. Coll. Will
Day, CF
37a William Kennedy Laurie Dickson, *Fun in
a Chinese Laundry* (Edison, 1894)

CHAPTER 4

CHAPTER 5

INDEX

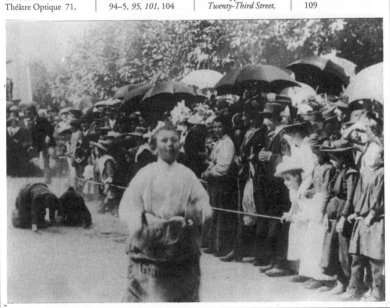

174

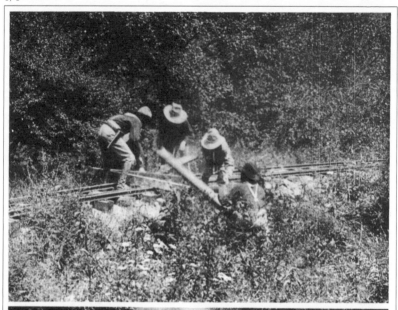

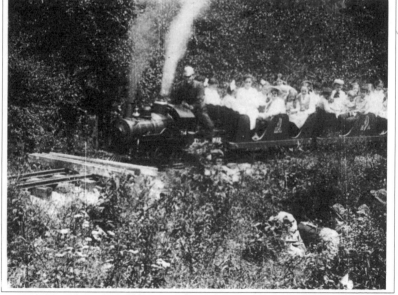

ACKNOWLEDGMENTS

The publishers would like to thank the following people and institutions for their help in the preparation of this book: Aldo Bernardini, Vicenza; Marie Borel, Noëlle Giret, Christine Petitot, Cinémathèque Française, Paris; Amanzio Borio, Museo Nazionale del Cinema, Turin; Eileen Bowser, MOMA, New York; Bernard Chardère, Institut Lumière, Lyons; Yasha David, Paris; Frédérique Desvergnes, CNAM, Paris; M. Dimitrio, Cinémathèque Suisse, Lausanne; Maxine Ducey, State Historical Society of Wisconsin, Madison; Claire Espilondo, FIAF 50, Paris; David Francis, British Film Institute, London; André Gaudreault, Suzanne Richard, GRAF, Laval University, Québec; Maurice Gianati, Paris; Jeanne Guillevic, Mme. Salvador, Musée Dupuy, Toulouse; Institut Jean-Vigo, Perpignan; International Federation of Film Archives, Brussels; Wolfgang Klaue, Staatliches Filmarchiv der DDR, Berlin; Library of the Institut Catholique, Paris; Madeleine Malthète-Méliès, Jacques Malthète, Paris; Miguel Marias, Filmoteca Española, Madrid; Michel Marie; Eva Orbanz, Berlin; Pierre Pitrou, photographer, Paris; Sylvie Pliskin, Cinémathèque Universitaire, Paris; Franz and Nicole Schmitt, Service des Archives de Film, Bois-d'Arcy; Science Museum Library, London; Tom Smith, American Federation of Arts, New York; Paul Spehr, Library of Congress, Washington; Giuseppe Valperga, Turin. Frédéric Dumas compiled the illustrations for this work and Pierre Pitrou photographed numerous documents. I. Mark Paris contributed invaluable research and translation assistance.

PHOTO CREDITS

All rights reserved 20–1, 23a, 28, 29, 31, 37a, 41b, 45, 47, 54a, 54bl, 59b, 71, 80, 93, 103b, 109, 122–3, 127a, 131, 160–1; American Federation of Arts, New York 90, 91b; Archives du Film, Bois-d'Arcy 76; British Film Institute, London 1, 4, 5a, 6, 7, 8, 9, 26, 44l, 74, 75b, 94–5, 95, 96–7, 98, 102, 104, 108, 112, 113, 114–5, 116, 117, 118–9, 120, 124–5, 125, 126, 127b, 142, 148–9, 152, 154, 174; British Film Institute (with the authorization of the Georges Méliès copyright holders) 62b, 101a; Cinémathèque Française, Paris 12, 13, 14a, 15, 16, 17b, 18, 19a, 19b, 21, 22, 23b, 24–5, 30–1, 32, 33, 34a, 36–7, 43, 44b, 46, 50a, 53, 57, 59a, 70, 77, 78–9, 79, 81, 100–1, 101b, 103a, 110, 111, 115, 121, 166, 173; Cinémathèque Française (with the authorization of the Georges Méliès copyright holders) 60b, 62b, 64b, 65, 88, 89, 141, 157, 159; Cinémathèque Suisse, Lausanne 37b; Cinémathèque Universitaire, Paris 5b, 73a; Cinéplus 42, 49b; Cineteca Española, Madrid 72–3, 73b; Collection Gianati, Pierre Pitrou stills, Paris back cover, 82, 83, 84, 85, 86, 87; Collection Malthète-Méliès, Paris 52, 61, 63, 64b, 66, 67, 68, 69, 99; Institut Jean–Vigo, Perpignan front cover, 2–3; Institut Lumière, Lyons 17a, 24, 27, 40–1, 134; Musée de la Publicité, Paris 75, 54br; Musée National des Arts et Traditions Populaires, Paris 51, 75a; Musée National des Techniques, CNAM, Paris 41a, 105, 140; Museo Nazionale del Cinema, Turin 14b, 25, 56, 58; Museum of Modern Art, New York 34b, 35r, 38, 60a, 91a, 92, 106, 107; Roger-Viollet 49a; Staatliches Filmarchiv der DDR, Berlin 39, 48; State Historical Society of Wisconsin, Madison 55

TEXT CREDITS

Grateful acknowledgment is made for use of material from the following works: (pp. 152–5) G. W. Bitzer, 'Filming My First War: 1898' from *Billy Bitzer: His Story*, copyright © 1973 by Ethel Bitzer; reprinted by permission of Farrar, Straus & Giroux, Inc. (pp. 150–1) Alice Guy, *Autobiographie d'une pionnière du cinéma (1873–1968)*, Denoël/Gonthier, 1976, translated by Andrew Litvack; reprinted by permission. (pp. 146–8) Cecil M. Hepworth, *Came the Dawn: Memories of a Film Pioneer*, J. M. Dent & Sons, Publishers, 1951. (pp. 134–7) 'Lumière, the Last Interview', *Sight and Sound*, Summer 1948; reprinted by courtesy of the British Film Institute. (p. 156) Terry Ramsaye, *A Million and One Nights: A History of the Motion Picture*, published by Simon and Schuster, New York, 1926; reprinted with permission of Mrs Terry Ramsaye on behalf of the Estate of Terry Ramsaye.

Emmanuelle Toulet
is a curator in the Department of Entertainment Arts
at the Bibliothèque Nationale in Paris,
where she is in charge of the film collection.
She has published several articles,
principally on the history of French silent films
and on safeguarding our
cinematographic heritage.

This book was produced with the kind collaboration
of the member cinematheques of the International
Federation of Film Archives (FIAF) in Brussels

© Gallimard/Réunion des Musées Nationaux 1988

English translation © Thames and Hudson Ltd,
London, 1995

Translated by Susan Emanuel

British Library Cataloguing-in-Publication Data

A catalogue record for this book is available from
the British Library

ISBN 0–500–30051–8

Printed and bound in Italy
by Editoriale Libraria, Trieste